JEWELLERS THE DIRECTORY

739.27 PAG
(3wk)

First published in Great Britain in 2007

A&C Black Publishers Ltd
38 Soho Square, London, W1D 3HB
www.acblack.com

Copyright © 2007

ISBN 978-0-7136-8409-4

A CIP catalogue record for this book is available from the British Library.

A&C Black exerts its right under the Copyright, Design and Patents Act, 1988, to be identified as the author of this work.

Edited by Sophie Page
Typeset by Karen Rowlings
Cover designed by Sutchinda Rangsi Thompson

This book is produced using paper that is made from wood grown in managed, sustainable forests. It is natural, renewable and recyclable. The logging and manufacturing processes conform to the environmental regulations of the country of origin.

Type set in Bembo and Frutiger

Printed and bound in China by C&C Offset

JEWELLERS THE DIRECTORY

A&C Black • London

INTRODUCTION

The Association for Contemporary Jewellery (ACJ) was founded as a non-selective membership association in 1997 and registered as a limited company in July 2006. The work represented in this directory is the result of an open invitation to our membership to participate in a special members' directory to coincide with our 10th anniversary in 2007.

The ACJ is the largest of at least eight other European jewellery associations and has succeeded in bucking the trend of decline, suffered by many membership groups in the past decade. Our steady growth from around the thirty-five original members in 1997 has enabled us to achieve regularly funded organisational status from the Arts Council, without whose support the ACJ would not have been able to achieve a fraction of the successful activities it runs and supports.

Based in the UK the association currently operates with around 750 members and is run primarily by volunteers and a small but dedicated number of part-time staff.

The ACJ currently encourages the growth of regional groups and has focal points based in London, Bristol, Berkshire, Manchester, Scotland, Ireland, Wessex and the Midlands. We organise workshops, lectures, seminars and every second or third year an international conference.

ACJ members comprise both the 'makers' (practising jewellers, associated designers, educators and students) and the 'owners or keepers' (collectors, curators, gallery owners and libraries). Together these members share interests and synergies between object and owner/collector and historian/maker and viewer. These facets represented within these pages reflect not only the enduring popularity of this special art form, but also the growth of a specialist association.

New trends and directions within jewellery are constantly evolving. At 'Origin', the Craft Council's new flagship fair at Somerset House in 2006, the clear increase in semi or non-precious materials on display was evident. 300 jewellers, over half of them ACJ members, were selected from around 1000 applicants to exhibit over two weeks in the marquee in the courtyard. Twenty-seven jewellers were listed under the category of 'non-precious' and forty-three under 'precious'. For a third consecutive year a non-precious jeweller was awarded the annual £1000 ACJ prize for their collection at the Crafts' Council's annual fair. This event was proof of a healthy, growing market for enlightened customers, accustomed to seeing work reflecting the skilled values of thought and labour above material.

Indeed an aim in 2004 of the 'Jewellery Unlimited' juried ACJ exhibition was clearly educational and 'to promote the area of contemporary jewellery to a wide audience, both locally and nationally'[1]. To this end the work of ninety-seven members was displayed at the Bristol City Museum and Art Gallery. Increasing an understanding and appreciation of contemporary jewellery is a core role of our work. In 2006 'Heirlooms' also provided another fascinating exhibition, on this occasion non-selected, of sixty-two rings in response to the question *"what, as contemporary jewellers will we be leaving behind through the artefacts we make today, for generations to come? What 'messages', both literally and implied, will these artefacts communicate to those that 1000 years from now might have relatively little knowledge of our current day and age"* [2]. These two important rationales are still very much alive and in our minds as we look forward to archiving a broad section of the work of our members within this publication.

Jewellery is one of, if not the, oldest of all art forms. The collecting, purchasing and commissioning of it is a rare pleasure, better still is the joy of giving it to another and the joy that it may bring. Finally this can only be surpassed by the act of making it oneself as I am sure can be appreciated from the statements and images within.

<div style="text-align: right">

STEPHEN E BOTTOMLEY
Chairman 2005-2007
Association for Contemporary Jewellery

</div>

[1] *Jewellery Unlimited*, 2004 ISBN 0953856011 p.13
[2] Callinicos, Elizabeth, *Heirlooms*, ACJ membership exhibition catalogue, 2006 ISBN 0948314508

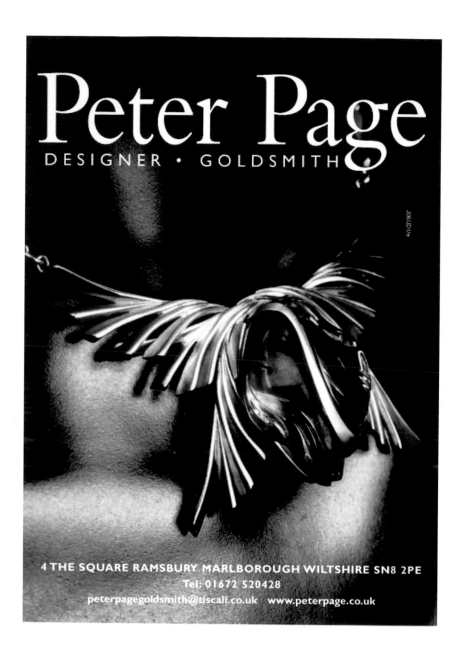

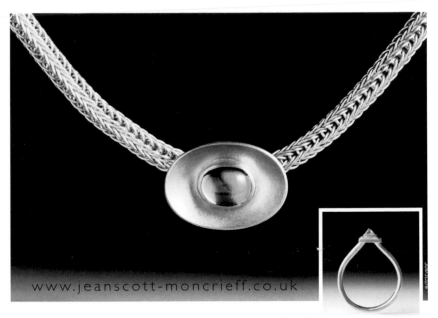

www.jeanscott-moncrieff.co.uk

18 carat gold chain with oval tourmaline pendant/22 carat gold ring with uncut octahedral diamond/photo FXP

JANE ADAM

Jane Adam has an international reputation for her innovative and sensitive jewellery in coloured anodised aluminium. This work can be seen in collections, exhibitions and galleries throughout the UK and abroad. She has taught and given lectures in many countries, and was a founder member and former chairman of the ACJ. She is currently a trustee of the Crafts Council.

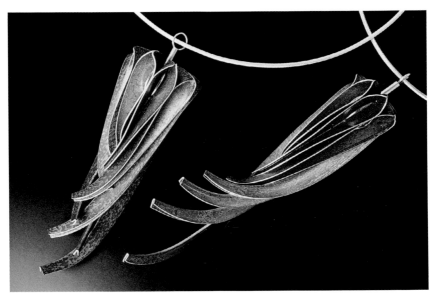

© Joël Degen

Flower pendants, 2006, dyed anodised aluminium, silver and 9ct gold, pendant on left: 10 x 5 cm

© Dick Barnatt

Unit W9, Cockpit Arts
Northington Street
London WC1N 2NP

tel. 020 7404 0947
email jane.adam@btconnect.com
web www.janeadam.com

WENDY AIKEN

Wendy Aiken's interest in making jewellery arose when she worked in India and saw jewellery being made at the side of the street. An HND at Sir John Cass School of Art enabled her to develop a range of jewellery sold through London and regional galleries. A visit to Japan was influential in developing designs featuring flowing lines and sinuous shapes, interweaving to form chains, chokers and necklaces.

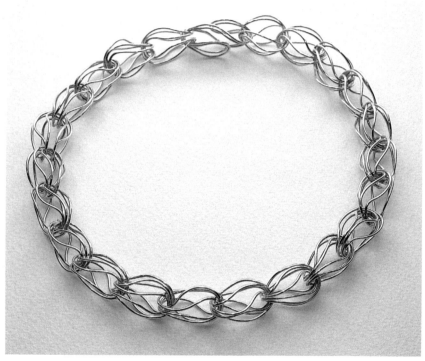

© S.M. Aiken

Double Loop, 2005, silver, 46 cm diameter

6 Ashley Meadows
Romsey
Hants SO51 7LT

tel. 01794 512954
email stuart.aiken@btinternet.com

Michael Alford Andrews previously travelled world-wide to remote areas to make award-winning BBC TV programmes on the natural world and archaeology. Native and historic objects and designs provide the inspiration for much of his jewellery. Whether pre-Columbian ceramics or Brazilian green-gold, he prefers to find or buy materials on site, giving his jewellery a uniquely personal and unrepeatable quality. Based in Bristol, he is pleased to accept commissions.

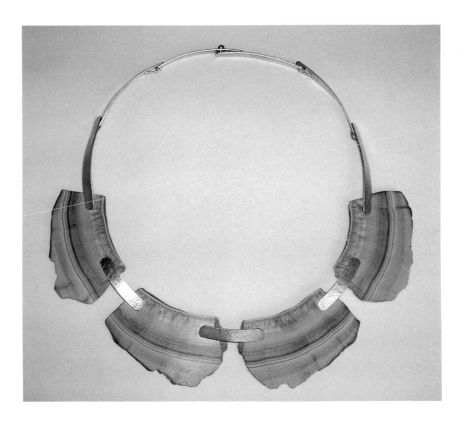

Necklace, 2005, malachite, gilded silver and 20ct gold, 18 cm diameter

28 Seawalls Road
Sneyd Park
Bristol BS9 1PG

tel. 0117 968 2140
email andrewsmj@onetel.net
web www.mlaandrews.com

PEPE ARGO

Pepe Argo designs unique jewellery made by hand in silver and gold, using carefully selected semi-precious stones and beads. Her inspiration lies in pattern – geometric, architectural or organic. The work depends on balance, strong shapes and subtle contrasts of surface texture. The results are always tactile, sensuous and made to adorn the body. Pepe's work is available through selected galleries or to commission.

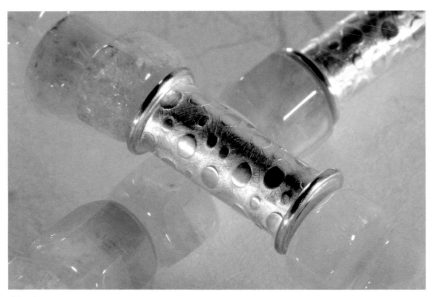

© Jon Stone

Necklace, 2006, silver, 18ct gold and aquamarine, 0.8 to 1.2 x 41.5 cm

tel. **01747 870364**
email **pepe.argo@btinternet.com**
web **www.pepeargo.com**

14

Sylvia Armstrong was a scientist, but changed direction by undertaking a course at the School of Jewellery and Silversmithing in Birmingham. She moved to Devon in 2002 and set up a workshop. She prefers simple shapes, with surfaces textured by melting or hammering the silver, or by rolling it with gauze, paper, or leaf skeletons, often using gold for contrast.

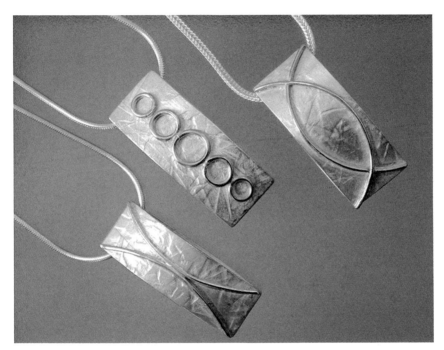

© Brian Harris

Silver Loop pendants, 2005, textured silver with 9ct gold wire trim, 3 x 1 cm approx.

Teignmouth
Devon

email sylvia.armstrong@btconnect.com

HIDEMI **ASANO**

Hidemi Asano was born in Japan and graduated BA in literature, however she chose a career as an artist in England where she studied jewellery making. Hidemi's aim is to harmonise her Japanese origin with life in U.K., interpreting the concept of Japanese minimalism with European jewellery making techniques which she applies to contemporary wearable jewellery, and from this she has developed her style.

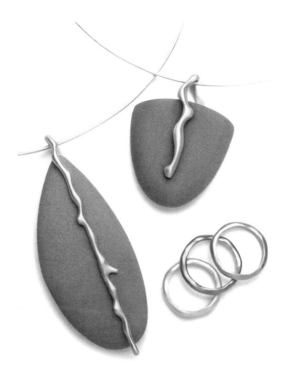

© Joël Degen

Branch rings & *Sara Sara* *neckpieces*, 2005, (ring) 18 ct Y & R gold, platinum, (neckpiece) silver and composite material, neckpiece: 4.5 x 3.5 cm long, 8 x 3 cm long

5 Peacock Yard
Iliffe Street
London SE17 3LH

tel. 07931 327664
email kirakira@onetel.com

ASIMI

Asimi features jewellery inspired by the organic textures found in volcanic and eroded rock. Gold, silver and rhodium are melted and fused to combine granular and smooth lava-like textures, then scattered with an array of high-quality precious stones. Each piece is hand-made and therefore unique.

Based between London and Greece, Anna exhibits in various European galleries, and works mainly to commission.

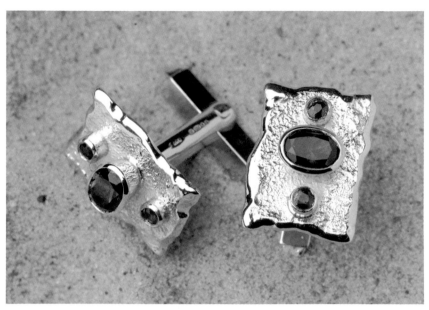

© Keith Parry

Oval 3 stone meteorite cufflinks, 2006, 18ct gold, rhodium, tourmaline and rubies, 1.8 x 1.3 cm

tel.	**0207 773 9980**
tel.	**0030 6937 772996**
email	**asimi.ab@virgin.net**
web	**www.asimi.org.uk**

JO BAGSHAW

Jo Bagshaw's jewellery collections are based upon questioning and challenging the idea of what is precious. She makes jewellery and body adornment from 'found' objects and throwaway materials and combines them with precious metals.
'I want to give these objects a new and valued meaning, a second life.'

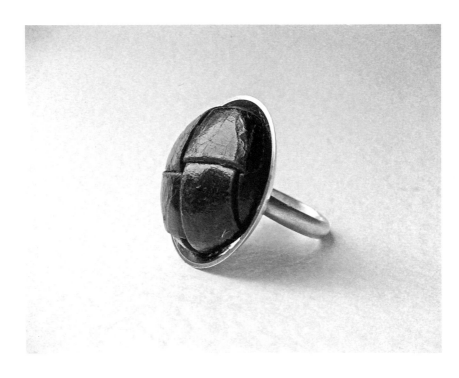

Leather button ring, 2005, leather button and sterling silver, 3.2 cm x 3.5 cm

York

mob. **07816 287283**
email **info@jobagshaw.co.uk**
web **www.jobagshaw.co.uk**

KATHLEEN BAILEY

Kathleen Bailey's work is inspired by archaeological jewellery finds and the effects time and nature have on materials. The castaway collection featured was created during a period spent on a Greek Island, using minimal tools, available materials and Mediterranean influence. The result is colourful hand-woven threads that support the beachcomber's amulets.

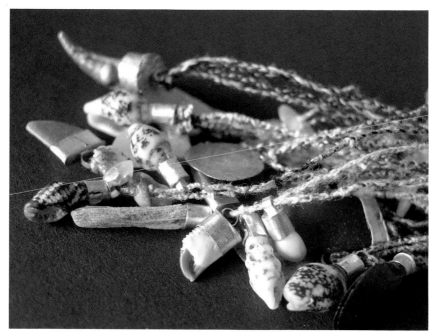

© Shaun Ludkin

Castaway collection / Beachcomber's amulets, 2006, shells, driftwood, glass, 18ct gold and cotton, 1.1 cm (size of coin)

© Shaun Ludkin

53 Springfield Road
Brighton BN1 6DF

tel. **01273 508033**
email **ktbailey7@yahoo.co.uk**
web **www.kathleenbailey.co.uk**

KATE BAJIC

Kate Bajic graduated from Loughborough University in 2003 with a BA (Hons) in Jewellery and Silversmithing. Since then she has exhibited in galleries nationwide with work appearing at prestigious events such as Dazzle at the National Theatre in London and Origin, The London Craft Fair at Somerset House. Kate runs day workshops at several galleries and also teaches silver jewellery evening classes at South Nottingham College.

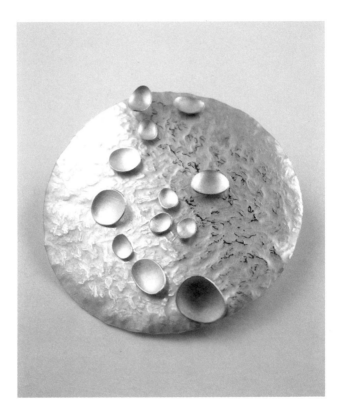

Textured scatter brooch, 2006, 18ct yellow gold, 5 cm diameter

mob. **07929 023699**
email **email@katebajic.co.uk**
web **www.katebajic.co.uk**

MAIKE BARTELDRES

Maike Barteldres is fascinated by stone. Its hardness and brittleness provide endless challenges, its texture and colouring provide exciting discoveries. She is interested in the everyday, non-precious stone. Brought down to jewellery scale, intricate details become apparent and it gains a preciousness in its own right. Her current work is the result of an exploration into the relationship between metal and stone and possible ways of connecting them.

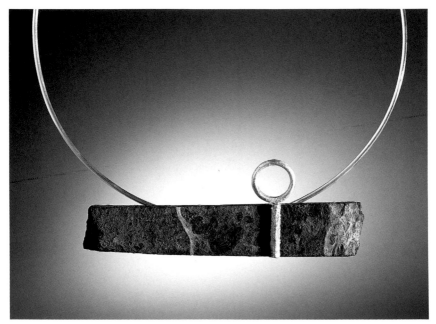

© Jason Ingram

Welsh torque, 2005, Welsh slate, silver, 13 x 4 x 1.5 cm (w x h x d)

mob. 07796 227983
email maike@madasafish.com
web www.maikebarteldres.com

LAURA BAXTER

Laura Baxter makes precious jewellery, wall panels and decorative metal screens inspired by botanical forms. Twigs, buds, blossom and leaf structures are abstracted and magnified in different scales to create graphic silhouettes of nature. The work reflects how plants change and grow throughout the seasons and explores intricate patterns found in plant life using light and shadow.

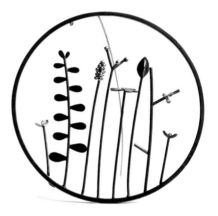

© Keith Leighton

Square Blossom brooch, Circular Plant Detail brooch, 2006, oxidised silver and 18ct gold, 7 x 7 cm, 8 cm diameter

2 Frederick Street
Farsley
Leeds LS28 5JB

tel. 0113 204 0492
mob. 07939 238608
email enquiries@laurabaxter.co.uk
web www.laurabaxter.co.uk

Nicola Becci produces a collection of etched and oxidised jewellery and small objects that are an exploration of decoration, using many diverse sources. In particular, the symbolism of religion and royalty, toys and calligraphy have all been influences, with more recently, confectionery and food inspiring her work.

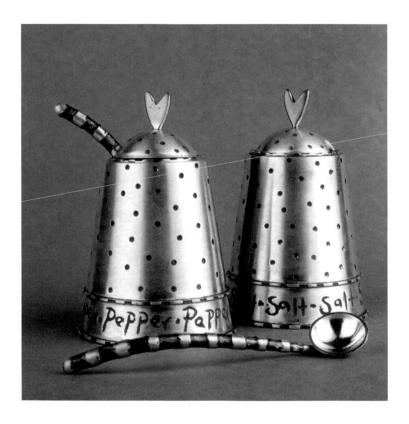

Salt & pepper set, 1998, precious white metal, brass and precious red metal, 7 cm high

107 Essex Drive
Jordanhill
Glasgow G14 9LX

tel. 0141 954 9000
email nbecci@hotmail.com

HOLLY BELSHER

Holly Belsher left the Royal College of Art in 1980, setting up her workshop in Clerkenwell, London before moving to Bristol in 1983. She makes several ranges of silver and gold jewellery using reticulation to give surface texture with semi-precious stone beads and freshwater pearls for colour. Originally influenced by ancient civilisations she now draws inspiration from the English landscape, flora and fauna.

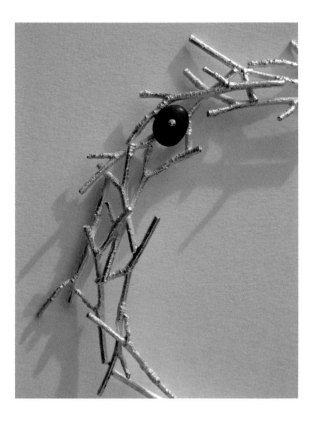

Silver twig necklace with pebble, 2004, silver and pebble, 18ct gold

email holly@hollybelsher.co.uk
web www.hollybelsher.co.uk

MATT BENTON

Matt Benton's brooches reflect an interest in the transformation of non-precious and ephemeral media into durable pieces, with a quality that transcends the nature of the materials used.

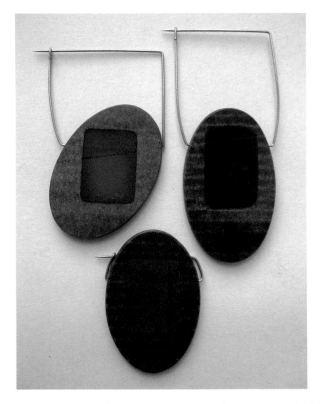

Three brooches, 2006, corrugated cardboard, epoxy resin, artist's pigment, brass and stainless steel, largest: 4.2 x 6 x 0.3 cm (w x h x d)

tel. **0117 977 4168**
email **matt.benton@btinternet.com**

15

ROSIE BILL

Rosie Bill started her career working for international fashion designer, Lara Bohinc, for whom she was her principal maker. In 2005 she set up her own studio in Leamington Spa. Her latest collection is called 'Lost and Found'. The pieces are predominantly made in silver, but include other people's discarded pottery, as well as petrified wood, mahogany and oak.

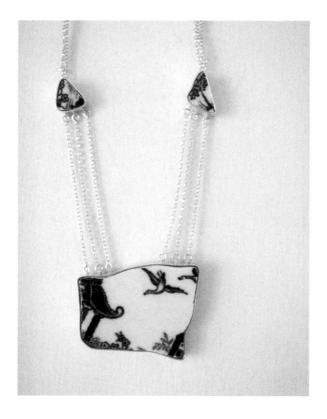

Willow pattern pendant, 2006, silver, main pendant 5.5 x 4 x 7 cm (w x h x d)

tel. **01926 741522**
email **rosiegbill@hotmail.com**
web **www.rosiebill.co.uk**

Carrie-Ann Black, originally from Yorkshire, crossed the Pennines to study Contemporary Jewellery Craft. Now living in Manchester, she works mainly in precious metals. Strongly influenced by architectural and sculptural form, she uses various techniques to create innovative and imaginative textures in her work. Carrie-Ann enthuses about the endless possibilities metal offers when creating a contemporary piece.

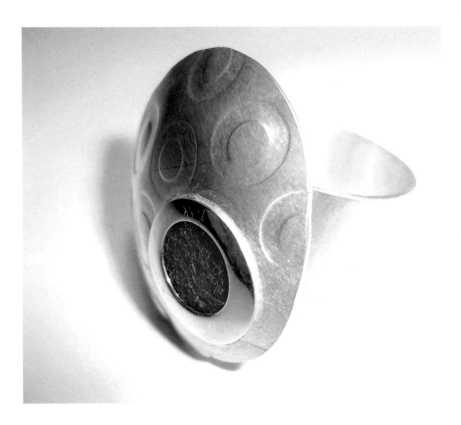

Ring, 2006, silver and felt

mob. **07766 540885**
email **carrie@carrieannblack.com**
web **www.carrieannblack.com**

ANGIE BOOTHROYD

Angie Boothroyd is a London-based designer and maker of contemporary jewellery in precious metals. Steeped in basic geometric principles, her work is both minimal and opulent. Angie completed her MA at the Royal College of Art in 2001 and has since exhibited and sold her work extensively throughout the UK and abroad.

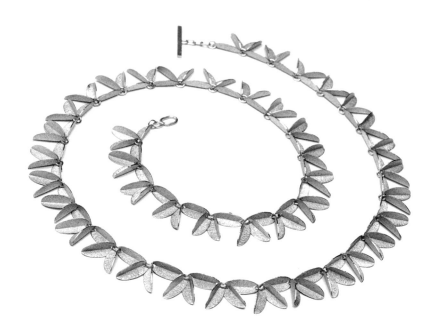

© Keith Leighton

'Palm' necklace, 2006, 18ct green gold, 22ct yellow gold and 22ct red gold

Studio E2G, Cockpit Arts
Cockpit Yard
Northington Street
London WC1N 2NP

tel. 020 7419 1152
email studio@angieboothroyd.com
web www.angieboothroyd.com

Stephen Bottomley was the fourth ACJ Chairman. He advocates the exploration of contemporary tools such as CAD/CAM alongside traditional techniques, to expand contemporary craft practice. 'Where these two worlds interweave is new territory that stimulates my creative imagination.'
Trained at the Royal College of Art (1999-2001) he is currently a senior lecturer for metalwork and jewellery at Sheffield Hallam University.

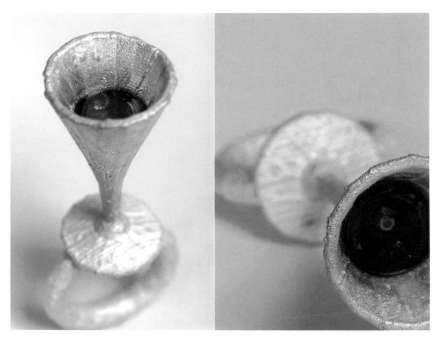

© Simone Nolden

Optimism for the future / Pessimism for the past?, 2006, electro-formed silver and amber, 8 cm high

email stephenbottomley@hotmail.com
web www.seb-goldsmith.com

CHERYL **BOWDEN**

Cheryl Bowden studied at Buckinghamshire Chiltern University College (BCUC). She gained a BA (Hons) in Silversmithing and Jewellery in 2001. Cheryl has exhibited in a number of exhibitions and galleries since leaving university and is currently working as a studio jeweller in Buckinghamshire.

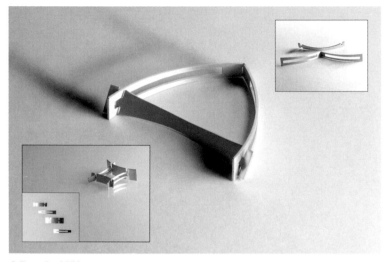

© Simon Goodchild

Floating levels, 2006, silver

mob. **07763 383166**
email **greenfairy1@btinternet.com**

Inge Braeckevelt trained as a designer jeweller in Antwerp, Belgium and moved to Bristol, UK in 1998. She has mainly been working to commission in the traditional way, although recently has developed some more commercial lines. She likes to draw on autobiographical material to ensure a narrative within her more artistic and eclectic jewellery, marrying tradition with new directions.

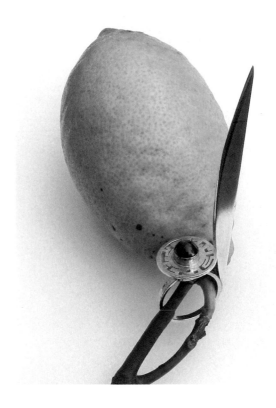

Knife ring, 2000, 18ct yellow, silver and star ruby

Bristol
UK

mob. **07796 127326**
email **inge.b@blueyonder.co.uk**
web **www.myspace.com/inge_b**

ABIGAIL **BROWN**

Abigail Brown studied Jewellery and Silversmithing at Loughborough University, graduating in 2001. She spent the following year at Bishopsland Workshops in Oxfordshire and in 2004 undertook a residency at Edinburgh College of Art. Her studio is now based in Cornwall where she also teaches jewellery and metalwork techniques at Truro College and at University College Falmouth.

© Ben Rowe

Square Folds brooch with hole pattern, 2007, fine sterling silver, 6 x 6 cm

© Jude Watton

Studio W11A
The Old Grammar School
West Park
Redruth
Cornwall TR15 3AJ

mob. 07752 011212
email abigailbrown37@hotmail.com

RUTA **BROWN**

Ruta Brown has developed a comprehensive personal vocabulary of form and texture by directly manipulating precious metals using hand tools and heat. Specialising in reticulation, her distinctive visual language is expressed through jewellery and small objects of silver and high-carat golds.

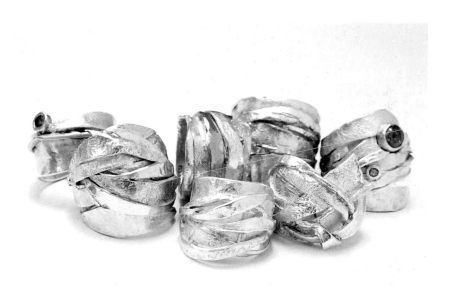

Seven rings, 2005, silver, 18ct gold, ruby, topaz and champagne diamond

c/o New Ashgate Gallery
Wagon Yard
Farnham
GU9 7PS

tel.	**01252 721185**
email	**info@rutabrown.co.uk**
web	**www.rutabrown.co.uk**

LILIAN **BUSCH**

She likes simplicity in design.
She likes a sparkling diamond on rusty metal.
She likes the mystery of black pearls on woven gold and silver.
She likes a rough, oxidised surface next to a highly polished edge.
And she likes to incorporate it all into jewellery that is easy to wear – and special!
Contemporary jewellery with a hint of tradition.

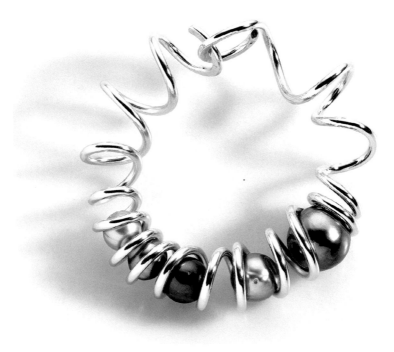

© Alistair Laidlaw

Winner of Tahitian Pearl Trophy 2005 UK - bangle, 9ct gold and tahitian pearls

tel. **01573 224863**
mob. **07791 183230**
email **lilianbusch@hotmail.com**
web **www.lilianbusch.com**

Lisa Cain has been making jewellery for seventeen years and teaching for over a decade. She now runs the Mid Cornwall school of Jewellery which has the widest range of jewellery related courses available at any independent school in England. Her speciality is bold, sculptural jewellery which forces the wearer into a conscious relationship with the piece.

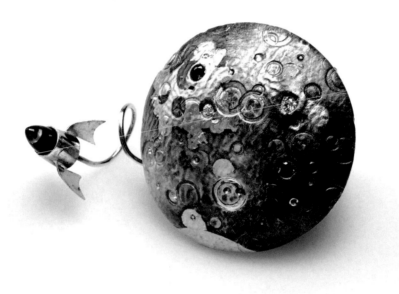

© Clive Carpenter

Fly me to the moon brooch, 2006, gold keumboo on precious metal clay, sterling silver, 18ct gold and blue topaz, 5 cm across

© F. Shaw

Mid Cornwall School of Jewellery
Treesmill Farm
Tywardreath Par
Cornwall PL24 2TX

tel. **01726 817989**
email **lisa@mcsj.co.uk**
web **www.mcsj.co.uk**

ELIZABETH CALLINICOS

Elizabeth Callinicos's recent collection of pieces are based on changing contexts and changing meaning. They explore issues related to vessels, both metaphorical and literal.

'The human being is my 'site': jewellery has become a vehicle through which I can explore a number of concerns, amongst these the interface between personal and public.'

Crucible lid, brooch, 2005, white metal, rubber, porcelain, 5 cm diameter

mob. 07905 003586
email ecallinicos@hotmail.com

MARTHA CAMARGO LAWRANCE

Martha Camargo Lawrance was born in Bogatá, Colombia where she studied architecture and interior design. She went on to study industrial design in Rome. After moving to England she worked in Oxford as a fashion designer. She now lives in Manchester where her interests turned first to Montessori teaching, and later to jewellery design. Martha finds the challenge presented by a piece of metal and its potential for transformation a constant joy.
'A thing of beauty is a joy forever.' (J. Keats 1818)

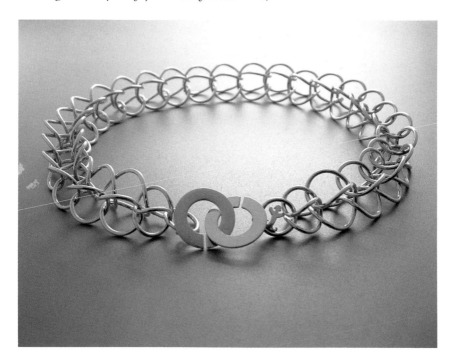

Loop necklace, 2004, sterling silver, 1.7 x 43 x 1.7 cm (w x h x d)

tel.	**0161 434 0638**
mob.	**07758 636170**
email	**mcl48@hotmail.co.uk**

YVONNE CHADDERTON

Yvonne Chadderton is inspired by water and sculpture. Her contemporary and sophisticated jewellery creations have clean, simple lines and at the same time are very sensuous and fluid. Her designs make a strong and dramatic statement, and the sculptural aspect of a piece is often emphasised by the use of a satin finish.

© Jonathan Keenan

Sails, 2004, 18ct yellow and white gold, 7.2 x 3.5 cm (excluding cable)

© Adrian Cornforth

tel.	**01706 378424**
mob.	**07768 327044**
email	**yvonne.chadderton@virgin.net**
web	**www.yc-jewellery.co.uk**

HANNE CHRISTENSEN

Hanne Christensen's Scandinavian upbringing has shaped the jewellery that she creates. Her designs are collections of decorative jewellery in silver with hand-crafted porcelain stones — almost sculptural in expression. Hanne hand-builds her jewellery pieces and these are directly connected to her experience with textile printing techniques. This is particularly evident in the 'Wave' and 'Bubble' collections.

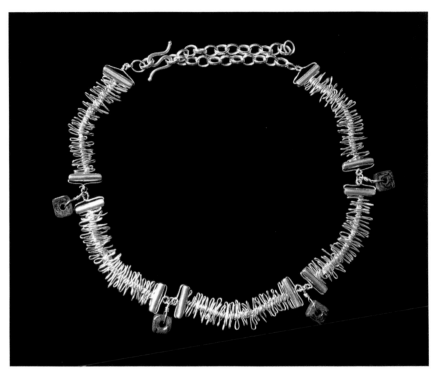

© Brian Capon

'Wave' link necklace, 2005, silver wire and handcrafted porcelain stones, adjustable length; core 35 cm plus chain

© Brian Capon

email hanne@hootaccessories.fsnet.co.uk
web www.hootaccessories.com

29

KATIE **CLARKE**

Katie Clarke's jewellery unites precious metals with feathers to create work that is both striking and original. Katie takes out of context the traditional method of fly-tying and combines the techniques with precious metals, to display feathers in bold and geometric patterns. The overall outcome is bright and varied in colour, intriguing in structure and attractive to wear.

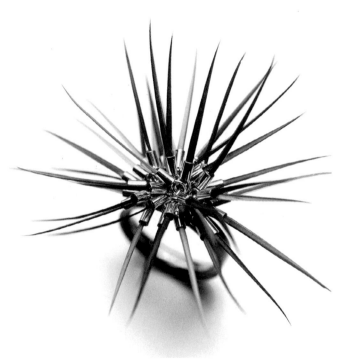

© Sophie Broadbridge

Sea urchin ring, 2003, silver and feather, 5 cm high

tel. 01483 569090
web www.katieclarke.co.uk

Andrew Coomber studied metalsmithing and fine art at Edinburgh College of Art, graduating in 1972. He ran studios in Edinburgh, Manchester and now North Wales producing 3D objects, jewellery and painting for exhibition and to commission. He has taught, written and managed applied/fine art programmes at undergraduate and postgraduate level. Programme leader for Jewellery/Metalwork at North East Wales Institute. He resigned from full-time teaching in 2002 to spend more time in the studio.

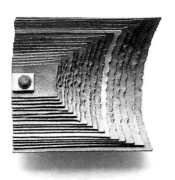
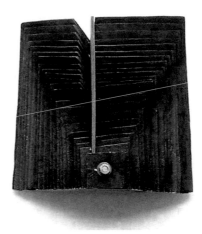

Quarry series - pins, 2005, dyed / anodised aluminium, gold, industrial fixings, 4 x 4 cm and 5 x 5 cm

tel. **01352 720846**
email **silver.quilt124@virgin.net**
web **www.axisartist.org/artistid/9817**

ROS COOPE

Ros Coope expresses her creativity in many ways, having spent several years working with textiles, design and technology. This has given her inspiration to design jewellery. She studied at the Bristol School of Art where she developed her own personal style in her work. Ros strives for precision, creating three dimensional, geometrical and innovatively constructed pieces which are uniquely textured.

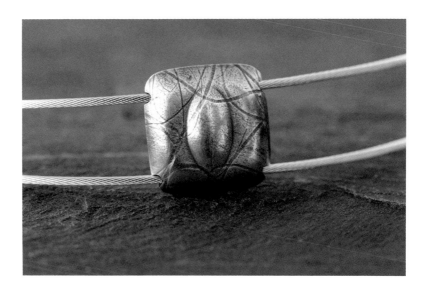

Timeless, 2006, oxidised silver, 2.3 x 2.3 x 0.5 cm (w x h x d)

email ros.co@btinternet.com
web www.roscoope.co.uk

KEREN CORNELIUS

Keren Cornelius rediscovers traditional needlework and textile skills in her inspiring range of contemporary jewellery. Exquisitely handcrafted for women desiring that elusive 'something special', these distinctive pieces drape softly around the neck, their delicate stitches finely worked in gold, silver, hand-spun silks and specialist threads – treasured pieces simply kept wrapped in paper and tied with string.

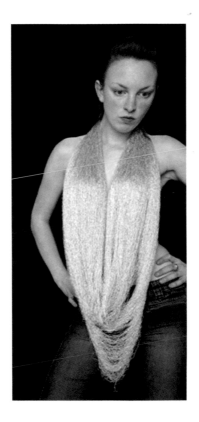

48 hours, 2006, embroidery thread, 85 cm long

mob. **07985 970948**
email **kerencornelius@hotmail.co.uk**
web **www.newdesignersonline.co.uk**

TOBY COTTERILL

Toby Cotterill's internationally exhibited jewellery is inspired by a passion for making and a palpable love of insects and sea creatures. His work develops from sketches and photographs, evolving on the workbench using traditional silver-smithing techniques. Forged silver forms, often articulated with handmade mechanisms and hinges, are combined with copper, resins or gemstones to create lively, humorous pieces of wearable sculpture.

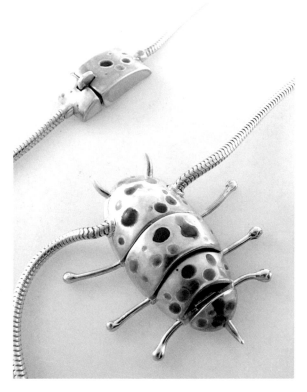

I think I'll just hang around here for a bit, 2005, neckpiece, sterling silver and resin, main body: 4.5 x 4 x 1.2 cm

mob. **07813 015448**
email **toby_cotterill@yahoo.com**
web **www.tobycotterill.co.uk**

Joanne Cox graduated in 2004 from the North Wales School of Art and Design with a BA (Hons) in Jewellery and Metalwork. Carnivorous plants and spider's webs inspire her anticlastic raised and intaglio textured pieces that combine silver, dyed nylon monofilament and anodised aluminium. The pieces are designed to attract and lure through colour and movement, and to subtly combine beauty with entrapment.

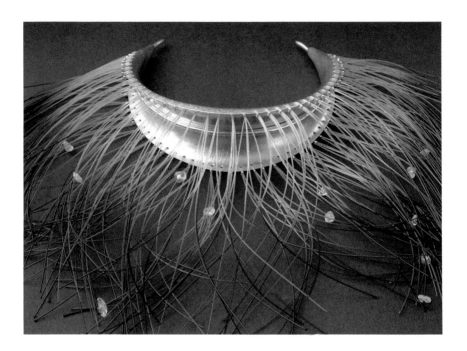

Allure neckpiece, 2004, silver, dyed nylon monofilament and rock crystal, 34 x 5 x 23 cm (w x h x d)

mob. 07986 478363
email jocox77@hotmail.com
web www.joannecox.co.uk

ANGELA B CRISPIN

Angela B. Crispin, an Anglo-Brazilian designer and maker, moved to France in 1987. She began making jewellery in Paris after receiving her degree in International Affairs in 1990, learning fabrication at both Formation BJO and at Nicolas Flamel. A certified PMC artisan, most of her work since 2003 has been focused on developing these techniques. Angela also teaches in France.

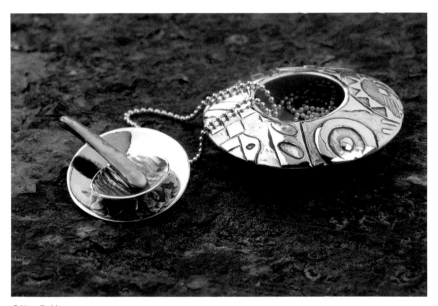

© Yvan Zedda

'My Home - My Treasure' box pendant, 2005, precious metal clay, abalone shell (paua shell) and black pearl (not shown) 6.5 diameter x 3 cm highest point (abalone tip)

© Elliot Baduel

France

tel. +0033 (0)6 1446 0607
email ange.est.la@wanadoo.fr
web www.langeestla.com

DANI CROMPTON

Dani Crompton completed a BA (Hons) in Silversmithing, Jewellery and Allied Crafts in 1999. She set up her studio in south-west London making high quality bespoke jewellery for every occasion, including wedding collections, in precious metals, Perspex, fine beading and many other matierials. She enjoys working to a brief and combining materials and techniques to create stunning and original designs.

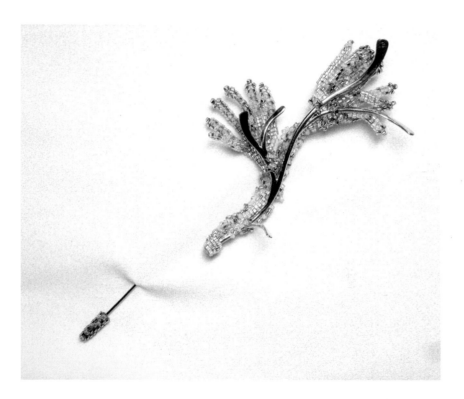

Golden coral brooch, 2006, 18ct gold and glass beads, 15 x 6 cm

6 High Cedar Drive
Wimbledon SW20 0NU

tel. **0208 947 4426**
email **dani@dani-c.co.uk**
web **www.dani-c.co.uk**

HANNAH DAVID

Hannah David makes jewellery from silver and semi-precious stones. She is inspired by natural forms, especially seaweed. Making gives her delight, and she hopes this is shared by the people who wear her pieces.

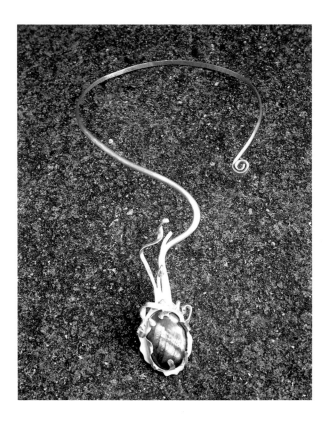

Neckpiece, 2006, sterling silver and labradorite, 35 x 20 cm

email hannahdavid@ukonline.co.uk

Penny Davis trained as a jeweller/silversmith at Sheffield Polytechnic. She then worked for a small independent jeweller for a couple of years. Since that time Penny has designed and manufactured her own work and commissions. She exhibits in a few London galleries and teaches enamelling and jewellery part-time at a number of colleges.

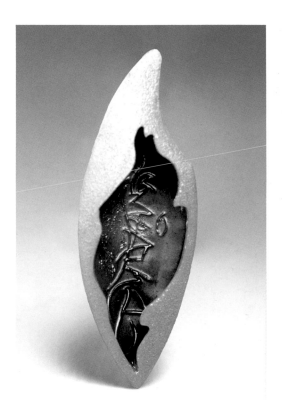

Graffiti pod brooch, 2005, sterling silver and enamel, 5.5 x 2.5 cm

tel. **01959 569721**
email **penny.d@virgin.net**
web **www.pdjewellery.co.uk**

GENNA DELANEY

Genna Delaney graduated from Duncan of Jordanstone College of Art and Design with BDes (Hons) in Jewellery and Metal Design in 2006. Architecture is a major influence, inspiring geometric forms and organic sculptures. Movement is also a prominent force where rare stones can be moved along the labyrinths of the work. Genna's pieces are tactile, sculptural and her kinetic designs have won a Goldsmiths Precious Metal Bursary Award.

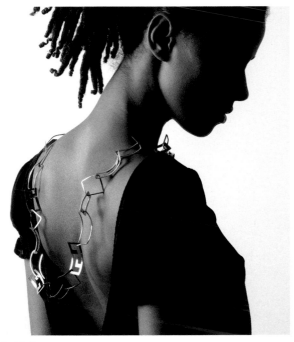

© Noel Shelley

Labyrinth neckpiece, 2006, silver, goldleaf, oxidisation with rolled detail, 1m long approx.

4 Blyth Place
Dundee DD2 2LX

mob. **07793 291050**
email **gennad_esign@hotmail.com**
web **www.gennadelaney.com**

Jane Dominese trained in Italy, Australia and Birmingham, and has been in the jewellery industry for over 20 years. Her work has a strong south-east Asian influence with simple, clean lines using primarily silver and fresh water pearls but also semi-precious stones and leather.

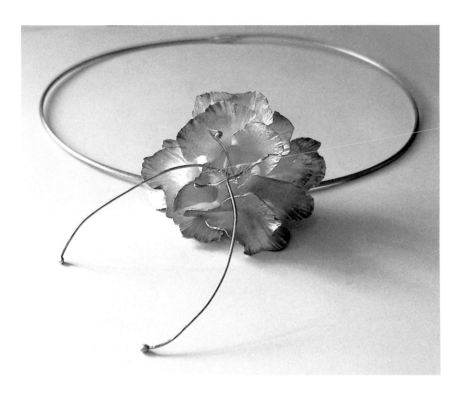

Flower pendant, 2005, silver, chain 28 cm long, flower 5 x 5 cm, stamens 5 cm long

Studio 1, Red House Glass Cone
High Street
Wordsley
Stourbridge
West Midlands DY8 4AZ

mob. 07952 597507
email janedominese@fsmail.net

ANNE EARLS BOYLAN

Anne Earls Boylan found herself irritated by a culture based on judgemental assumptions and this frustration became the 'grit' in the oyster shell of a jeweller's mind. She found that through objects it was easier to comment on and question values, politics and gender. Materials become the collaborator in a covert operation that questions the narrow minded conventions and provides a discreet means of communication.

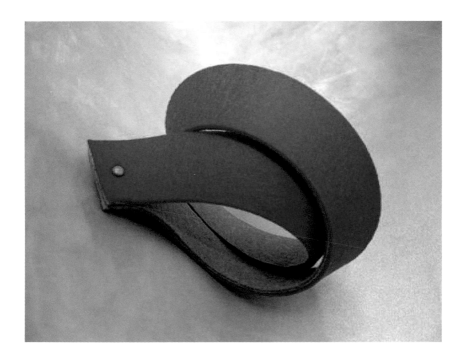

Felt cuff, 2006, felt with enamel brass butterfly clip, 15 x 6 cm

The Scutch Mill
16 Mill Road
Ballygowan
Co. Down BT23 6NG

tel. 02890 815440
mob. 07951 727935
email anneearlsboylan@aol.com

Georgina Ettridge's collections are sensitive representations of organic forms, crafted in precious metal to reflect the beauty of nature. Fluid rhythms within woodland settings, specifically the New Forest, provide inspiration for her designs. She uses photography to record the enticing features within these natural habitats, and pieces are created using a variety of techniques to produce unique, miniature, wearable sculptures.

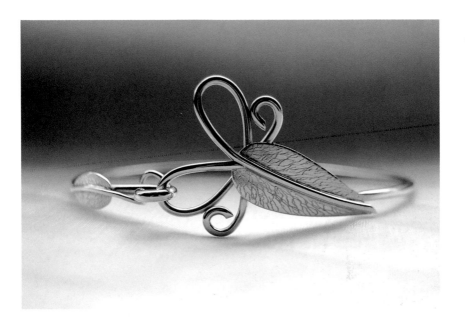

Flowing leaf and tendril bangle, 2006, yellow and white gold, 7.5 x 3 cm

Southampton
Hampshire

tel. 02380 736704
email designer@georginaettridge.co.uk
web www.georginaettridge.co.uk

ALISON EVANS

Alison Evans' jewellery, based on traditional chainmail techniques, is concerned with touch and movement. The textile-like qualities of the metal links fall naturally. These pieces have an internal architecture of form and simplicity that is balanced by an exuberant play of luminosity and shade. Stones and pearls provide colour, enhancing the reflective and dynamic sensibilities of these works.

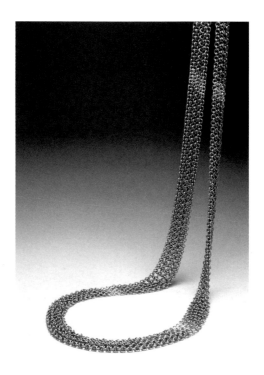

© Joel Degen

Titanium and 18ct gold long Necklace, 2006, titanium and 18ct gold

tel. **01825 872716**
email alison@alisonevans.com
web www.alisonevans.com

44

Louise Frances Evans explores narratives of identity, women's work and domesticity through installations. Her pieces voice the expectations surrounding women to be a 'good girl', to be 'beautiful' or a 'loving mother'. She is interested in the maternal line and in skills, such as sewing, and objects, such as jewellery, which women pass on to women.

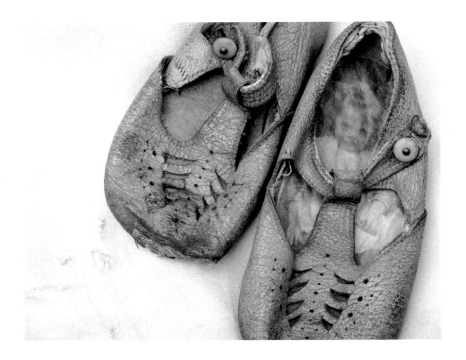

Girl from installation: 'What are little girls made of?', 2005, vintage shoes, handfelt and abraded fabric transfer, 15 x 15 x 5 cm (w x h x d)

email louise@louisefrancesevans.com
web www.louisefrancesevans.com

ANDREAS **FABIAN**

Common currency:
The mirror is a vehicle of self-reflection, of self: individual responsibility above and beyond national boundaries for which a coin might normally stand.

© Studio Orion Dahlman

Mirror (stripped and polished Euro coin), 2002, white and yellow base metal, 2.3 cm diameter

tel. **01494 605106**
email **a.fabian@gmx.net**

Ruth Facey trained at Central School of Art & Design (DipAD) and also has an MA in Design History. Working mainly in silver, often with gold for details, a variety of surface finishes characterises her work that also features non-traditional settings for semi-precious stones. She has a small gallery attached to her workshop and welcomes visitors by appointment.

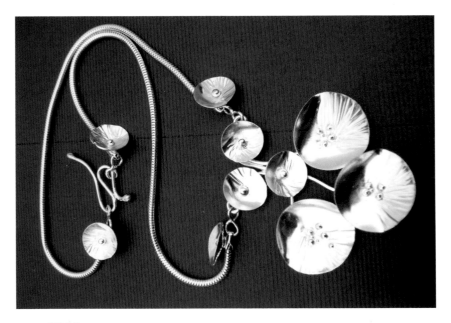

© Ruth Facey

Silver textured dish necklace with granule detail, 9 x 8 cm plus snake chain

2a Bishops Way
Andover
Hampshire SP10 3EH

email studio@ruthfacey.co.uk
web www.ruthfacey.co.uk

SHELBY FERRIS **FITZPATRICK**

Shelby Ferris Fitzpatrick specialises in unique work created around concepts. This 'Responsible ring' contains the report titled Dirty Metals: Mining Communities and the Environment, requesting mining companies to meet basic standards in their operations, plus images of open-pit mining. Created in the hope that makers, retailers, and customers who use, sell or buy gold will take an active part in ensuring that human rights and the environment are not abused.

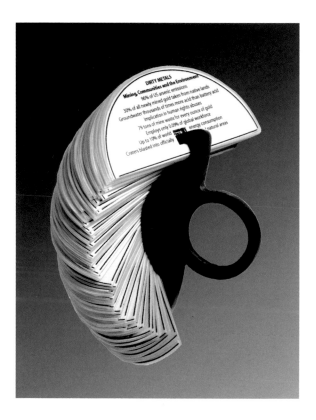

Responsible ring, 2006, paper and plastic, 8 x 11 x 6 cm (w x h x d)

tel. **01227 710554**
email **shelby.fitzpatrick@clickvision.co.uk**
web **www.shelbyfitzpatrick.com**

Emma Gale graduated in 1995 with a first class honours degree in Jewellery from Edinburgh College of Art. In 2006 she received a Creative Development Grant from The Scottish Arts Council to produce a new collection of work. Emma is co-author of *Teach Yourself Jewellery Making* published by Hodder and Stoughton. Her work can now be seen in galleries throughout Britain and internationally.

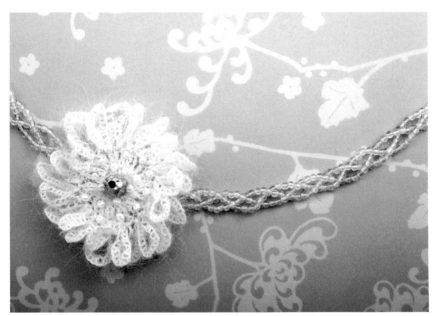

© Graham Clark

Moon daisy choker, 2006, kid mohair, pearls, citrine beads and 18ct yellow gold

© Graham Clark

2 West End
Brompton by Sawdon
Scarborough
North Yorkshire YO13 9DQ

mob. 07806 765193
email info@emmagalejewellery.co.uk
web www.emmagalejewellery.co.uk

49

RACHEL GALLEY

Rachel Galley graduated from Central Saint Martins in 2004 and has worked with Links of London, Stephen Webster and Boodles. Her latest collection of gold and silver pieces is based on the concept of remembrance and treasured memories. 'Globe' features Rachel's signature textured contemporary lockets, whilst 'Pillow' is formed from soft, square signature textured elements – allowing glimpses of hidden gold.

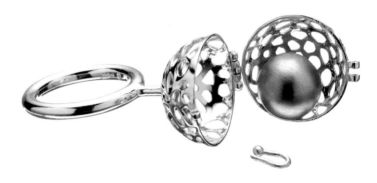

© Dave Hare

Memento Globe locket ring, 2006, silver and 18ct gold, globe 2 cm diameter

Studio E15, Cockpits Arts
Cockpit Yard
Northington Street
London WC1N 2NP

mob. 07732 890744
email rachel@rachelgalley.com
web www.rachelgalley.com

ALASTAIR **GILL** FSDC

Alastair Gill was born in 1954. He studied architecture at Bristol University in the 70's and went on to practice architecture until the early 90's. Inspired by exhibitions at the Arnolfini in Bristol and elsewhere, jewellery designing and making started for him in the mid 70's and continues. He is an elected Fellow of the Society of Designer Craftsmen.

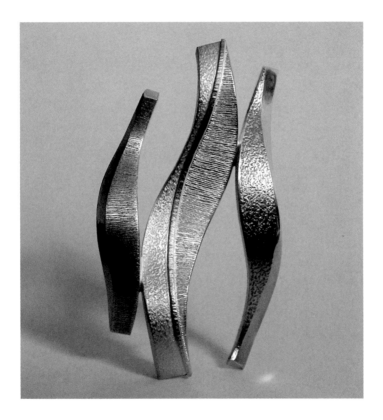

Fragments brooch, 2005, silver and 18ct gold, 5 x 3 cm

web www.fineringsandthings.co.uk

LYNNE GLAZZARD

Lynne Glazzard is a jewellery designer and maker with a special interest in colour. She creates colourful jewellery in enamel, silver and dyed anodised aluminium. Her work is inspired by patterns found in the landscape, from places as varied as the Yorkshire Moors and the streets and cityscape of Rome. She has an MA in Design from the University of Lincoln.

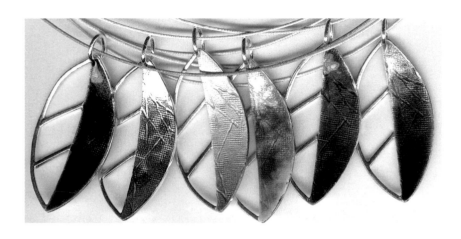

Leaf pendants, 2006, enamel on silver, hallmarked, 4.7 x 2.2 cm (excluding chain)

Glaisdale
North Yorkshire

tel. **01947 897788**
email **info@lynne-glazzard.com**
web **www.lynne-glazzard.com**

Rowena Golton designs and creates jewellery ranges, commissions and collectable exhibition pieces from her studio in south Manchester. Her designs echo a sense of profound simplicity and elegance to the more complex and symbolic. Working mainly in sterling silver her handcrafted pieces adorn the wearer as 'small works of art' giving a sense of individuality and style.

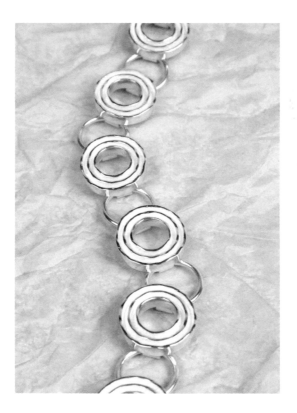

Crinkle bracelet, 2003, sterling silver, 19 x 1.3 cm

mob. **07050 610506**
email **rowenagolton@yahoo.co.uk**
web **www.rowenagolton.com**

RUTH **GORDON**

Ruth Gordon's work is inspired by an investigation of the colours, textures and patterns found in cakes and sweets. Ruth's passion for colour and texture has lead her to dye nylon monofilament and use brightly coloured enamels and plastics, which she heat-forms, and combines with silver, corrugated with steel presses.

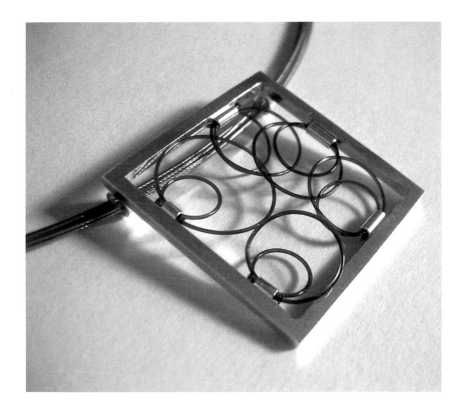

Blue nylon framed necklace, 2006, silver and dyed nylon, 46 cm neckwire x 3 cm pendant

Old Schoolhouse
Knapp
Inchture
Perthshire PH14 9SW

mob. 07812 033024
email ruthkgordon@hotmail.com
web www.ruthgordonjewellery.co.uk

Mary Graham knits coloured wire into exciting one-off sculptural forms, which are equally at ease lying on the window ledge or pinned onto clothing. Inspired by natural forms, she uses wool, wire and beads to create jewellery pieces using textile techniques. She also makes simple jewellery from her textured porcelain beads.

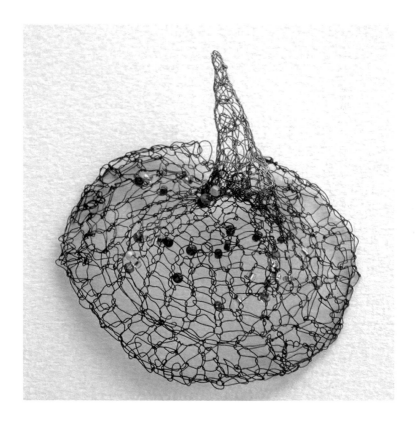

Spiky, 2006, coated copper wire, glass seed beads, 2.5 x 6 x 7 cm (w x h x d)

68 Myrtle Avenue
Long Eaton
Nottingham NG10 3LY

tel. 0115 972 9029
email mgraham@ukonline.co.uk

NIGEL HARVEY **GRAHAM**

Nigel Graham handcrafts jewellery in all the precious metals. Incorporating precious and semi-precious stones he is inspired by the ideologies and ethics of the Arts and Crafts Movement and the playful imagery of Heath Robinson and Roland Emett. He likes to work closely with clients so they can experience the magic of the making process.

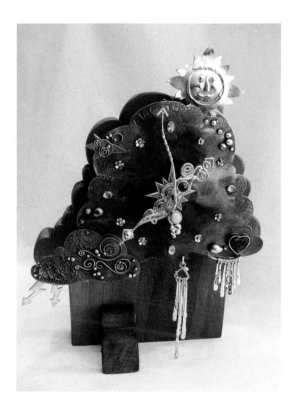

Clock, 2005, oxidised silver 18ct yellow gold, peridot, ruby, garnet and turquoise, 12 x 21.5 cm

18 South Street
Eastbourne
East Sussex BN21 4XF

tel. 01323 649023
email info@nigelgraham.com
web www.nigelgraham.com

Chris Green is course director of the BA (Hons) Designed Metalwork and Jewellery and BA (Hons) Jewellery courses at BCUC. In his own creative work Chris is interested in exploring the boundaries between silversmithing and jewellery, as in these silver and gold tea stirrers which combine the symbolic function of the wedding ring with the act of stirring tea.

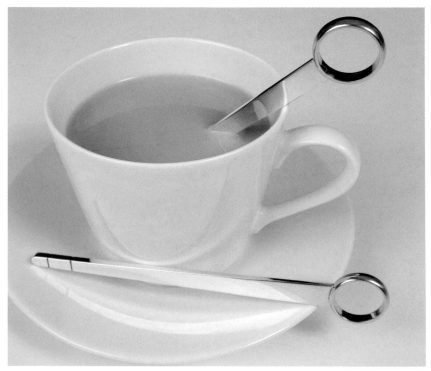

© Andy Halecredit

Tea for two, 2006, 9ct gold and sterling silver, 12.5 x 2 cm

tel. **01628 600414**
email **cgreen01@bcuc.ac.uk**

MASAKO HAMAGUCHI

Masako Hamaguchi's work delves down to the essentials of what jewellery is. Her fascination is with its beating heart, exposed as costly materials and artistic achievement are flayed away. She asks how the jeweller transmutes her base materials, how is value bodied forth? Now, in her latest work Hamaguchi paces the corridor where alchemy sublimates the mere object into the beloved.

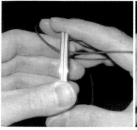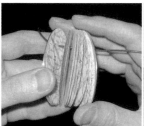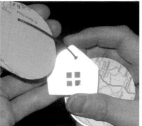

© Peter Crush

Untitled, 2006, silver 925, mother of pearl, old maps and leather, pendant (closed) 5.7 cm x 0.4 cm

© Peter Crush

mob. 07758 370583
email masako_u_k@yahoo.co.jp

JANE HAY

Jane Hay was born and educated in Scotland. After leaving school she worked in a jewellery workshop where she learned the basic skills of her discipline. In 1980 she moved to Surrey where she obtained a degree in Three-Dimensional Design. Her work reflects her love of colour and texture in a combination of materials including precious stones, pearls and textiles.

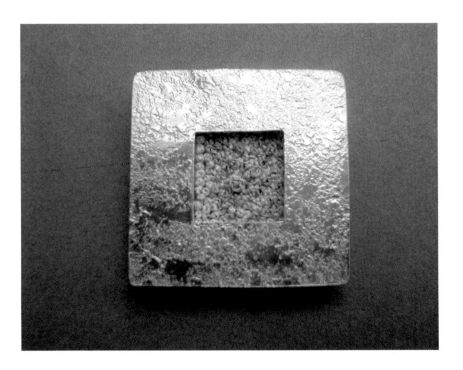

Silver textured pendant with embroidery, 2003, silver and hand-embroidered silk, 3 x 3 x 0.5 cm (w x h x d)

6 Treadwell Road
Epsom
Surrey KT18 5JW

tel. **01372 818136**
email jane.hay2@ntlworld.com
web www.janehayjewellery.co.uk

JOANNE HAYWOOD

Joanne Haywood's work explores the essence of materials and the permanence of jewellery as physical objects and a transitional idea. Wire compositions are altered by charcoal and wood oxidisation. She draws on the contradiction and conflicts of opposites: skeletal forms and fleshy volumes, natural and unnatural, the absence of colour and the addition of colour, light and shadow, within and beyond control.

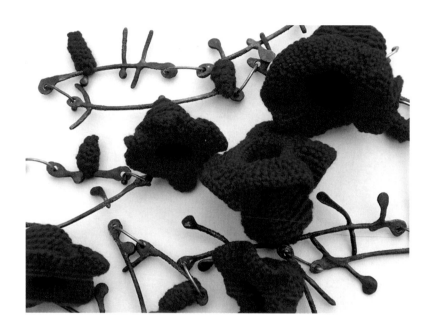

Red neckpiece, 2006, charcoal oxidised silver and crocheted elements

51 Danson Lane
Welling
Kent DA16 2BQ

mob. 07862 273934
email joannehaywood51@hotmail.com
web www.joannehaywood.co.uk

Colette Hazelwood is a designer maker of contemporary jewellery whose work is innovative and challenging, from her 'Squash – The Gobstopper Mouthpiece' to her 'Hearing Aid' jewellery. The regional winner of the Shell Livewire Young Entrepreneur Award 2002, she was commissioned by the BBC for the Royal Television Society Awards 2005. Colette's other commissions include private and public, with pieces owned by Grundy Art Gallery, and MIMA.

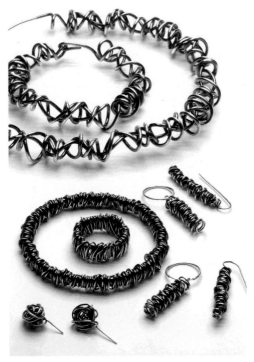

© Dave Burrows

Wraparound range, oxidised silver

Studio 4
Manchester Craft & Design Centre
17 Oak Street
Manchester M4 5JD

tel. 0161 839 0030
email info@colettehazelwoodjewellery.co.uk
web www.colettehazelwoodjewellery.co.uk

LOEKIE HEINTZBERGER

Loekie Heintzberger's work creates a world in which she combines innovative ideas with designs of the purest simplicity. Her collection includes a variety of uniquely crafted individual pieces and small production lines. Gold is the main material used in Heintzberger's work. She incorporates elements of elegance, movement and flexibility often combining precious and unconventional materials, making her work unique.

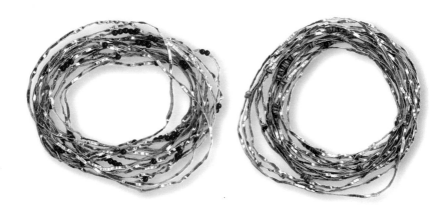

Rain necklaces with coral and turquoise, 2005, 18ct yellow gold, coral and turquoise, 280 cm x 0.3 cm

Korhoenstraat 14
1911WH
Uitgeest
The Netherlands

tel. 0031 (0)629 444 325
email loekieheinzberger@hotmail.com
web www.loekieheintzberger.com

© Ton per Jaar

Ashley Heminway took her degree in craft through Brighton University, and studied metal, ceramics and glass. She works with copper, silver and enamel to produce individual one-off pieces and small collections as well as commissioned work. Ashley is currently part of the team at Hastings College and works with all ages and abilities teaching metalwork and jewellery.

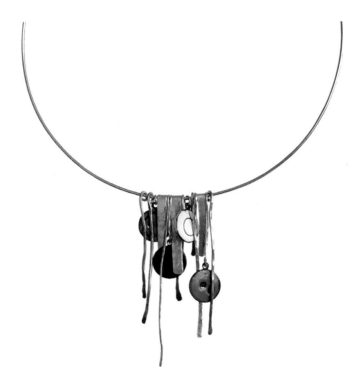

© Andrew Scrase

Fragments in time, 2006, silver and enamel, 18 x 22 cm

© Andrew Scrase

mob. 07704 611812
email ajheminway@tiscali.co.uk
web www.myspace.com/ashleyheminway

FIONNA HESKETH

Fionna Hesketh's education in jewellery making started at school and includes a BA (Hons) from the Central School of Art. Since setting up her workshop in 1986, Fionna has worked to private commission, exhibition, and supplied galleries in Britain. She also teaches jewellery. Her work covers a range of techniques, including forging, enamelling and gem-setting. Her designs are simple and classic.

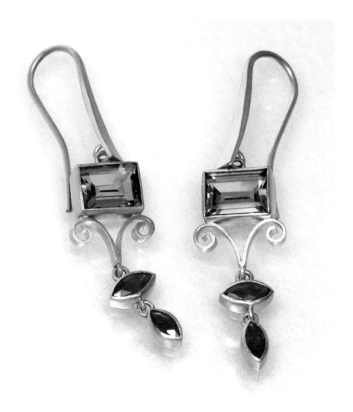

Earrings, 2006, 18ct gold with peridot and rubies, 5 x 1.4 cm

tel. 01453 764151
web www.fionnahesketh.co.uk

Alice Highet is a Designer and Jeweller dedicated to making quality and distinctive pieces for contemporary and spirited people. Contrasting colourful plastics with silver, traditional silversmithing techniques are fused with digital technologies. Alice takes diverse inspiration from organic structures, science fiction, toys and kinetic art, creating sculptural one-off pieces alongside playful and wearable production jewellery.

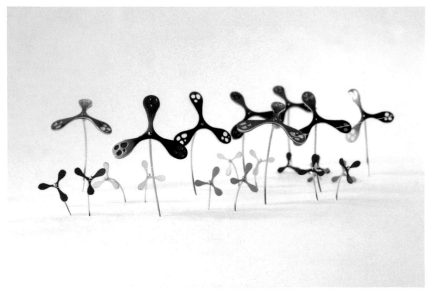

© Steven Landles

Helicopter brooches and studs, 2006, polypropylene, brooches 6 cm tall, studs 2 cm tall

mob. **07751 087189**
email **mail@alicehighetjewellery.com**
web **www.alicehighetjewellery.com**

JANET HINCHLIFFE McCUTCHEON

Janet Hinchliffe McCutcheon is a designer based in north-east England. Her jewellery designs represent strong line and pared down forms in precious metals, ebony and silk cord. When worn the pieces provoke interaction with the wearer such as necklaces where components may be repositioned at will. The range of designs also includes rings, brooches, earrings and cufflinks.

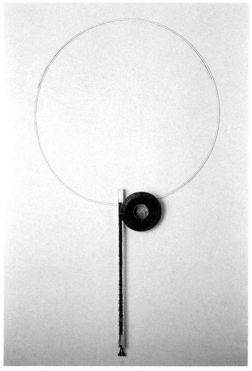

© Joël Degen

Necklace, 2006, silver, gold leaf, silk, 10 cm long

P.O. Box 464
Middlesborough
TS1 9DB

tel. 01642 817891
mob. 07779 197063
email jan.hinchliffe@unn.ac.uk

Professor **Dorothy Hogg** has been involved with the education of students at various art colleges for several decades. For 22 years her involvement has been with Edinburgh College of Art as Head of the Jewellery and Silversmithing Department. Her subconscious mind drives her aesthetic and events and changes in her life are reflected in an abstract way in her work. The structure and movement of the body with related symbolic thoughts preoccupy her design process.

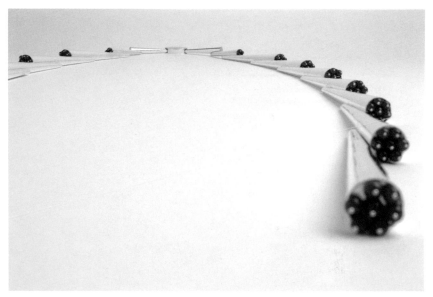

© John K. McGregor

Neckpiece in the artery series (collection of Birmingham Museum and Art Gallery), 2005, silver, gold and red beads, 107 cm long, diameter of cone terminals 1.2 cm

c/o **The Scottish Gallery**
16 Dundas Street
Edinburgh EH3 6HZ

email dorothy_hogg@hotmail.com

© John K. McGrego

TERRY HUNT

Terry Hunt's work exploits repetitive patterns; computer generated and machine engraved onto silver, aluminium and titanium. This creates, at different scales, precise and deliberate statements. Post-process techniques such as anodising and patination soften the strict machine aesthetic. Terry is deputy head at the UCE School of Jewellery, Birmingham and has had work exhibited in numerous galleries in England and abroad.

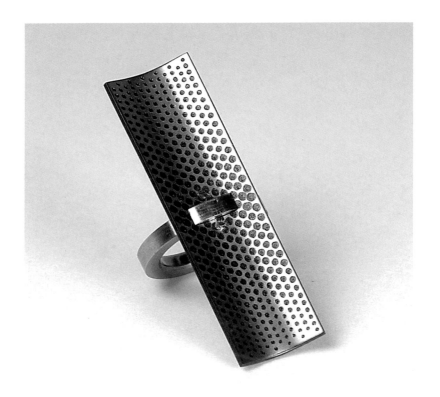

Finger ring, 2004, titanium, steel and gold, 6 x 2 cm

U.C.E. School of Jewellery
Vittoria Street
Birmingham B1 3PA

tel. 0121 331 6478
email terry.hunt@uce.ac.uk

MELISSA **HUNT**

Melissa Hunt makes jewellery inspired by her surroundings: sea-worn glass and pebble pieces collected during her childhood on the South Coast, a collection of men's jewellery featuring areas of the A-Z whilst living in London; and more latterly a new range influenced by the hills, plants and riverscapes of the Shropshire countryside. Melissa is a part-time tutor at the City Literary Institute, London.

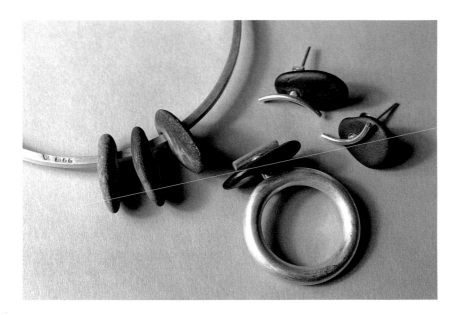

Silver and stone jewellery, 2001, silver and black pebbles, earrings 11.5 cm long, bangle width: 9 cm, ring 2.5 x 0.5 cm

1 Hatfield Terrace
Shrewsbury
Shropshire SY3 8QG

mob. **07931 351233**
email **melissahuntjewellery@hotmail.com**
web **www.melissahuntjewellery.co.uk**

NICOLA HURST

Nicola Hurst, designer and maker of contemporary jewellery, has been hand-making jewellery professionally since 1995, having completed a Jewellery BA (Hons) degree in 1990 at Middlesex Polytechnic. Nicola incorporates silver and gold with precious and non-precious stones in some pieces, and simply silver or gold in others. All Nicola's jewellery is beautifully elegant, contemporary and easy to wear. The inspiration for designs comes from Nicola's fascination of architecture, clean and simple lines and her love of making the jewellery. New collections are frequently produced as well as many one-off pieces. Commissions undertaken.

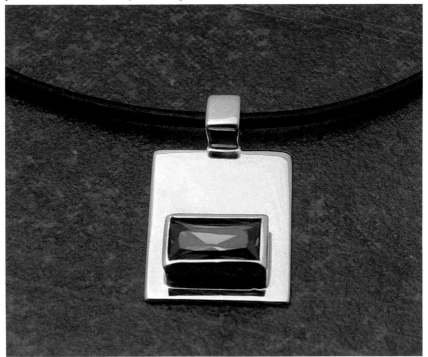

© Eliot Siegel

Gold pendant, 2006, 9ct gold and CZ, 1.7 x 2.5 cm

65 Hyde Park Road
Plymouth PL3 4JN

tel. 01752 228000
email nicola@nicolahurst.co.uk
web www.nicolahurst.co.uk

Jill Hutchings' neckpiece is part of an ongoing exploration combining fabric, felt and beading. The repetitive, almost meditative process is the reason for making the work and is integral to the appearance of the finished item.

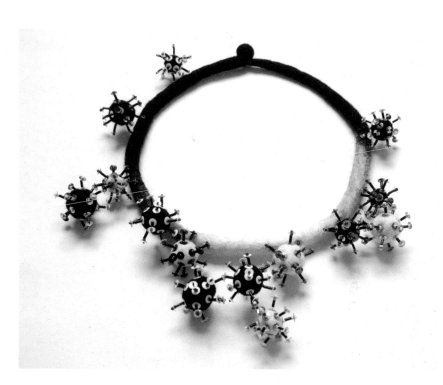

Neckpiece, 2006, felt, sequins and beads, 22 cm diameter

email g.m.hutchings@btinternet.com

STEPHANIE JOHNSON

Stephanie Johnson has developed a range of jewellery using pleated and folded silver, delicately textured and embellished with gold detail.

She fuses, imprints and manipulates metal using traditional tools, but with a creative and experimental approach to processes and techniques.

Some qualities in her work are a response to patterns and textures observed in nature; others reflect her fascination with contemporary Japanese textiles.

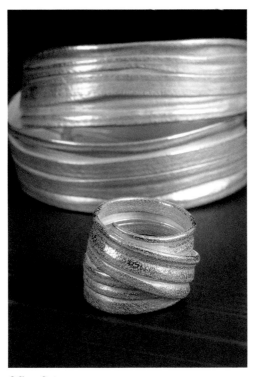

© Simon Burt

Silver double wrap ring and bangle, 2005, silver

© Clare Bird

tel. **01326 313875**
email **stephaniejohnson6@btinternet.com**

Sharon Justice trained at Portsmouth College of Art from 1978-1982 gaining a Southern Regional Diploma in 3D Design; in the 1980s she gained 3 platinum awards. Currently working predominantly in silver she is producing designs incorporating forging and applied surface texture techniques.

Her influences are applied pattern forms, ranging from architectural through to textile, ancient to modern.

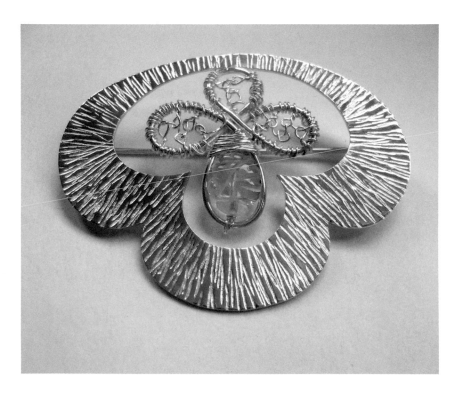

Silver and citrine brooch, 2005, silver, 5.3 x 3.7 cm

email sharon.justice@ntlworld.com

TANVI **KANT**

Tanvi Kant creates work ranging from delicate everyday jewellery to larger statement pieces. She combines porcelain forms with reclaimed textiles. These include waste or unwanted fabrics, such as items of clothing, furnishing and dress-making fabrics. Tanvi creates one-off pieces, makes to order and works to commission, as well as exhibiting and selling through galleries in the UK and internationally.

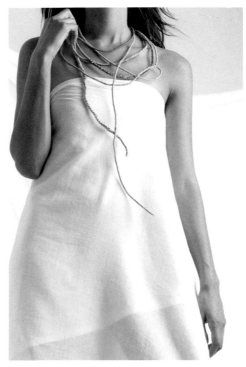

© Tas Kyprianou

Long green and gold wrap, 2006, sari fabric and thread, 300 cm long

mob. **07973 551661**
email **info@tanvikant.co.uk**
web **www.tanvikant.co.uk**

Donna Keay's work is inspired by historical jewellery, antique books and their gold-tooled cover patterns, archaeological finds and the theme of memory. Etching allows fragments of historical patterns or text to be reproduced on the metal. The finished pieces combine etched panels with simple outlines, translating these themes into contemporary, wearable jewellery.

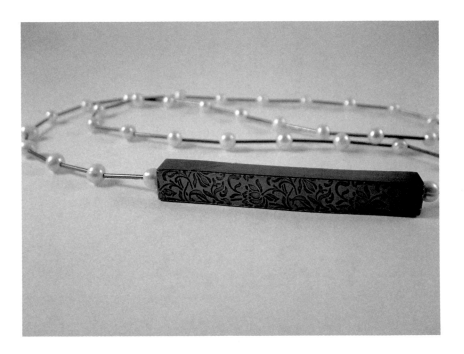

Necklace, 2006, sterling silver and freshwater pearls, necklace: 80 cm long, box: 7.2 x 1 cm

email mail@donnakeay.co.uk
web www.donnakeay.co.uk

SARAH KEAY

Sarah Keay has taken part in numerous international group and solo exhibitions since graduating in 2003. She has gained many prominent commissions including one to produce three large-scale knitted drapes for the touring exhibition Cutting Edge, organised by the National Museums of Scotland. Stockists of her work include Contemporary Applied Arts in London.

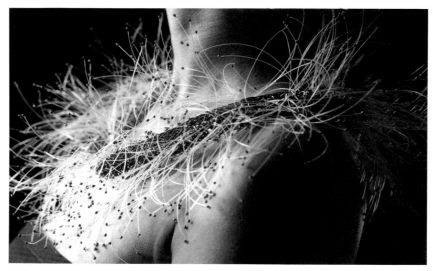

© Shannon Tofts

Green necklace, 2005, enamelled wire, monofilament, silver and enamel, 40 x 3 cm approx.

© K. Koppe

70 Forthill Road
Broughty Ferry
Dundee DD5 3DN

tel. **01382 775847**
mob. **07870 735305**
email **sarahisobelkeay@hotmail.com**

Sarah Kettley's jewellery is an integral part of her work in interaction design. Awarded an AHRC Arts and Science Fellowship in 2006, she reflects on contemporary craft to analyse the impact of design processes on the experience of the wearer of new forms of digital product. Unusual materials and emerging technologies are compellingly combined in a highly textural formal language.

Bi-valve (development piece for ensemble jewellery and sound project), 2006, resin, formica and silver, 8 x 4.5 x 1 cm (w x h x d)

5 Mortonhall Park Loan
Edinburgh EH17 8SN

tel. 0131 620 1342
mob. 07980 609515
email s.kettley@napier.ac.uk
web www.dcs.napier.ac.uk/~cs179/
 sarah-kettley/

TANYA KRACKOWIZER

Tanya Krackowizer was born in South Africa and began her jewellery career in earnest when she graduated from Middlesex University in 1993. Whilst outworking for several jewellers including Reema Pachachi and Wright & Teague, she designed her own contemporary collection which is now sold nationwide. She also produces commission work varying from a necklace of 14th century nails to platinum and diamond earrings.

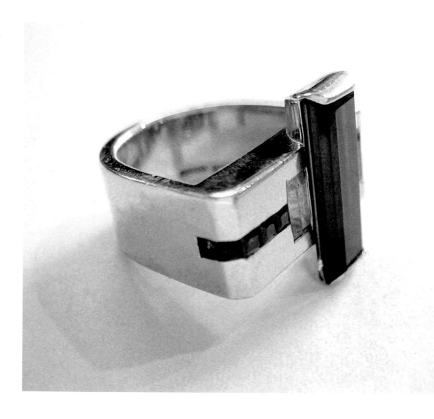

Tourmaline dress ring, 2004, 18ct white gold set with a green tourmaline, aquamarines and sapphires

tel. **01621 818538**
email **tanya@tlk-jeweller.com**
web **www.tlk-jeweller.com**

DAPHNE **KRINOS**

Daphne Krinos was born in Greece. She established her studio in London after studying at Middlesex University and getting a Setting Up Grant from the Crafts Council in 1982. She has exhibited widely and her work is held in several public and private collections. Her work is featured in many books published in the UK and the US and can be seen in several UK galleries.

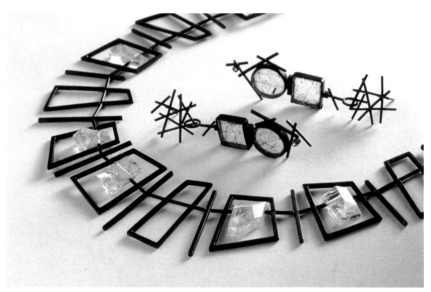

© FXP

Black necklace and earrings, 2006, oxidised silver, aquamarines, morganite and ruilated quartz, necklace 47 cm long, earrings 6cm long

42 Groombridge Road
London E9 7DP

tel. **020 8986 2328**
email **daphnekrinos@aol.com**
web **www.daphnekrinos.com**

DOMINIQUE **LABORDERY**

Dominique Labordery's work requires movement, analysis and contemplation. It needs to be discovered again and again. Her intention is to combine graphical forms, clear structures and sensitivity of colour. This expression of form is created by precise craftsmanship, using traditional techniques and a mix of materials.
Each piece of jewellery is a world in itself, allowing space for individual interpretation...

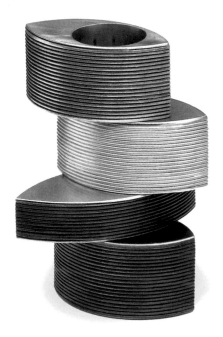

TULIP rings, 2005, gold, silver and oxidised silver, 4 x 2 cm

Bürgerstrasse 20
40219 Düsseldorf
Germany

tel. 0049 211 310 6895
tel. 0049 177 395 3583
email info@labordery.com
web www.labordery.com

Sue Lane's jewellery stem from experimentation with line and proportion, with a particular interest in architectural townscapes. By stripping away the majority of intricate detailing, but working with one aspect and using it as a feature, Sue creates sculptural and wearable pieces of jewellery.

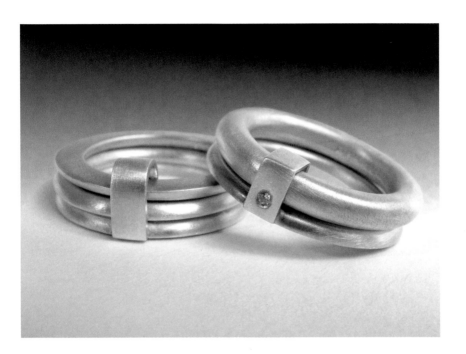

Two rings, 2006, silver and gold

Herefordshire

tel. **01885 488836**
email **info@suelanejewellery.co.uk**
web **www.suelanejewellery.co.uk**

SALLY LEES

Sally Lees designs and makes limited edition jewellery with an emphasis on exquisite men's cufflinks. Polished, anodised aluminium sheet is decorated with bold brush strokes to create modern patterns, then dyed magnificent colours. Additional collections show delicate, intricate patterns taken from original line drawings of orchids and roses printed onto mirror-like surfaces reminiscent of Japanese lacquer.

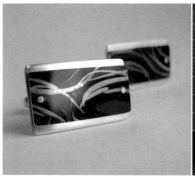

© Electronic Marketsquares (Model shot)

Aluminium cufflinks, 2006, aluminium and white metal

Cockpit Arts
Northington Street
London WC1N 2NP

email sally@sallylees.com
web www.sallylees.com

CAROLE **LEONARD**

Carole Leonard's ideas come from the properties of the materials used. An important consideration is the transient quality of materials and the interaction between the wearer and the worn. Recent work has used steel, precious metals and sheet Perspex. These materials allow the combination of colour and pattern within a simple outline shape, contrasting the tactile qualities of warm and cold, rough and smooth surfaces against the body.

Spiral ring, 2006, silver / sheet perspex, 2.5 x 3 x 0.8 cm (w x h x d)

Cricks Green Cottage
Stoke Lacy
Herefordshire HR7 4HB

tel. 01885 490371
email caroleleonardjewellery@gmail.com

ANNA LEWIS

Anna Lewis is a contemporary jewellery designer based in Wales. She has exhibited her one-off collections of jewellery and larger body pieces widely throughout the UK and overseas. Her work has been featured in several magazines including Crafts, Elle Decoration and Living etc. Her jewellery is inspired by themes of memory and superstition and include delicately printed feathers and suede combined with silver and found components.

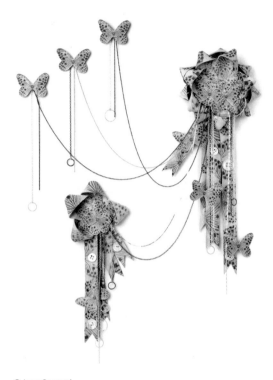

© Jesse Seaward

Butterfly skirt pin, 2005, printed suede and silver, 30 x 40 cm

79 Gorwydd Road
Gowerton
Swansea SA4 3AG

tel. 01792 875836
email info@annalewisjewellery.co.uk
web www.annalewisjewellery.co.uk

Tina Lilienthal graduated from the Royal College of Art in 2003 with an MA in Goldsmithing, Silversmithing, Metalwork and Jewellery. Her work focuses on the unconventional mixture of materials such as plastics and fabrics in combination with precious elements like silver, gold and pearls. Whilst the use of colours creates a fresh vibrant look, the symbolic undertone of her pieces adds an element of playfulness. Tina's collections range from bold exhibition pieces to wearable jewellery and fashion jewellery.

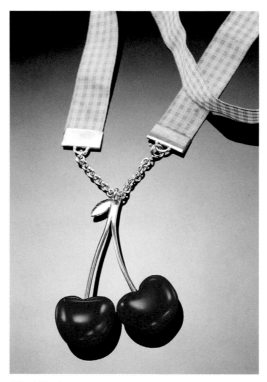

© Frank Thurston

Double cherry necklace, 2004, sterling silver, resin and ribbon, pendant: 5 cm long, necklace: 43 cm long

email info@tinalilienthal.com
web www.tinalilienthal.com

SARA LLOYD-MORRIS

Sara Lloyd-Morris's passion for making jewellery began with a demonstration of lost wax casting while still at school. Graduating from the School of Jewellery and Silversmithing, Hockley, Birmingham, Sara moved to London to work for Andre Grima of Jermyn Street, who worked By Appointment to HRH. After this she started her own company and has been making jewellery ever since. Sara is a member of the Makers Guild in Wales.

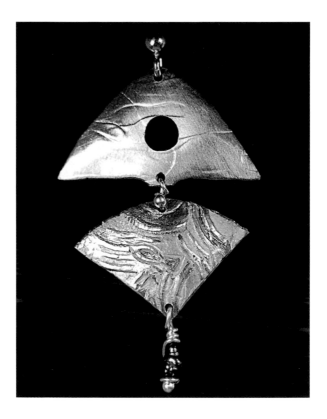

Earring, 2007, brass, silver, 24ct and pearl, 3.5 cm long

email info@saralloyd-morris.co.uk
web www.saralloyd-morris.co.uk

Carole Lockwood comes from a background in diamond mounting and royal regalia therefore it is understandable that she works mostly on commissioned pieces in precious metals. Carole explores colour, texture and form incorporating enamel, gemstones and other materials relevant to a particular piece. Her inspirational sources are as diverse as nature to mechanical and architectural structures with an interest in kinetics.

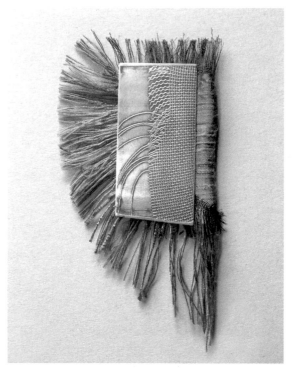

© Tony Lockwood

Frayed # 1 brooch, 2003, silver and silk, 10.5 x 5.5 cm

© Tony Lockwood

Longwell Green
Bristol

tel. **0117 949 2097**
email **carolelockwood@blueyonder.co.uk**

CLAIRE LOWE

Claire Lowe's work is influenced by form, texture and colour, and is very much about exploration and combination of materials including mixed-media, metal and plastics (mainly resin). Her current collection combines metal, epoxy resin and tea leaves; this range of jewellery is inspired by the tradition of tea drinking, the collection has followed on from her graduate pieces. Claire graduated 18 months ago and since then has been extending her range as well as commissioning pieces for specific exhibitions. She sells her work through galleries, shops and craft fairs and has recently designed her own website.

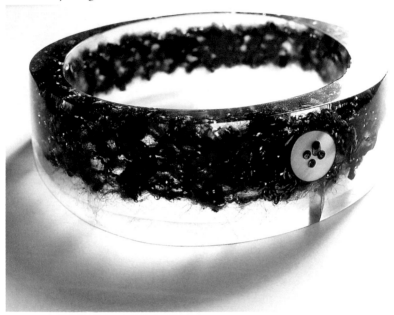

Knitted bangle, 2004, resin, wool and button, 8 x 11 x 2 cm (w x h x d)

tel. **07717 307444**
email claireloweresin@hotmail.com
web www.clairelowe.co.uk

JANE MACINTOSH

Jane Macintosh trained at Sir John Cass School of Art and started a workshop in 1982. She has exhibited throughout the UK and also in the USA. All her jewellery is individually made, often combining different precious metals apparently seamlessly, so they enhance each other and add depth to the clean lines of her designs which are inspired by the urban landscape.

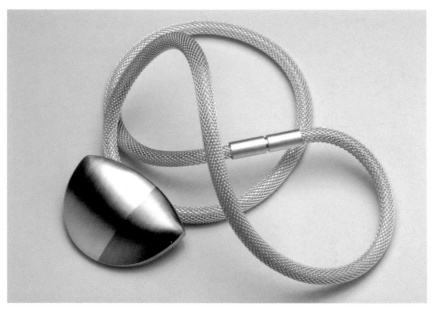

© Joel Degen

Pendant, 2006, silver and 18ct white gold, 3.5 x 2.5 cm

London SW4

tel.	020 7720 0406
tel.	020 7720 4265
email	janemacintosh28@tiscali.co.uk
web	www.janemacintosh.com

JOAN MACKARELL

Joan MacKarell works with enamel, and in her most recent pieces she combines unusual talismanic stones with textured and matt finished glass, resulting in highly individual necklaces, imbued with a uniquely elemental and spiritual feeling. In addition to making jewellery and small work, she undertakes public commissions, and has work in private and public collections both here and abroad.

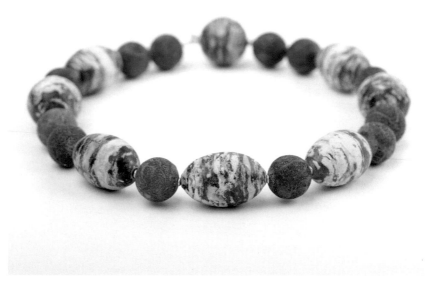

© Full Focus

Hot Rock necklace, 2005, enamel, copper, coral and silver, 45 cm long

96 Erlanger Road
London SE14 5TH

tel. 0207 639 2472
email j.mackarell@virgin.net
web www.studiofusiongallery.co.uk

ALISON **MACLEOD**

Alison Macleod takes inspiration from old objects and the memories they retain of previous owners. These uniquely precious and mysterious qualities are translated into her jewellery. She combines beaded wire with individual wax castings, flat pierced shapes, found objects and semi-precious stones to reflect her subject matter in a quirky way. Alison works full time from her workshop in Glasgow, Scotland.

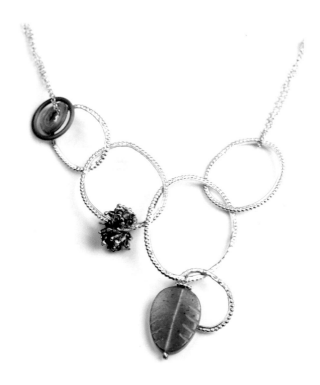

© Shannon Tofts

Random Cameo Necklet, 2006, silver, aventurine, smoky quartz, antique mother of pearl, button and bra bits

WASPS Studio 206
77 Hanson Street
Glasgow G31 2HF

Mob. 07786 434981
email alibmac@hotmail.com
web www.alisonmacleod.com

91

SARAH MACRAE

Sarah Macrae continually reinterprates the penannular brooch as a form, where the functional elements are integral to the design. Recent pieces investigate the optical possibilities of using translucent acrylic by carving and creating lens-like elements. Alongside her studio practice Sarah teaches part-time at West Dean College. She exhibits regularly with The Designer Jewellers Group.

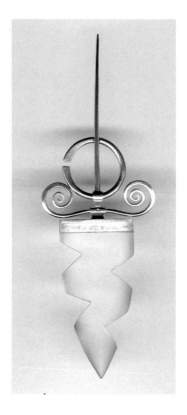

Acrylic penannular brooch, 2006, silver and acrylic, 11.5 x 4 cm

tel. **02392 348813**
email **sarahmacrae2@yahoo.co.uk**
web www.designerjewellersgroup.co.uk

Gill Mallett's inquisitive approach to her work has resulted in the development of techniques involving partially or wholly melting metals to create different effects. The results become the starting point from which her innovative designs emanate. Gill has recently started offering workshops whereby clients can melt their own gold and, together with Gill, create their own individual piece of jewellery.

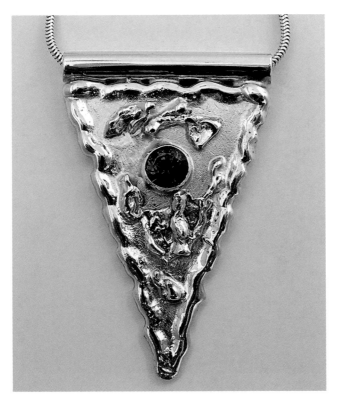

Fire & Ice pendant with tanzanite (in private collection), 2006, 18ct yellow and white gold with tanzanite

P.O. Box 3162
Ferndown
Dorset BH22 2BL

tel. 01202 873917
email gillery@btinternet.com
web www.gillery.co.uk

LINDSEY MANN

Lindsey Mann graduated from Middlesex University in 2002 with a first class honors degree in Jewellery. Since graduating she has received awards from both Arts Council Southeast and the Crafts Council Development Award. Lindsey's playful jewellery is stocked and exhibited throughout the UK and abroad, and she has made jewellery and larger scale installation work for both public and private collections.

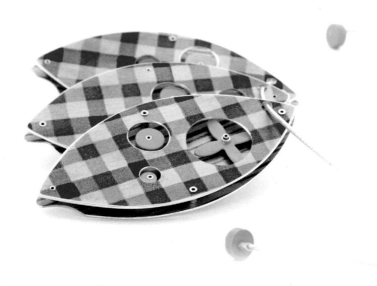

© Helen Gell

Propeller pendants, 2004, printed anodised aluminium, vintage plastics and silver, penants each 6 x 3 x 0.5 cm (w x h x d)

The Colour Factory
The Lodge, 1 Gordon Road
Winchester SO23 7DD

tel. 01962 870789
email lindsey@lindseymann.co.uk
web www.lindseymann.co.uk

Al **Marshall**'s designs are simplistic in form, standing as little pieces of sculpture in their own right. They are highlighted with texture, colour and stones and are inspired by forms found in architecture and man-made structures. His jewellery and boxes often feature articulated elements or cunningly disguised clasps and frequently display a sense of humour or an unexpected twist.

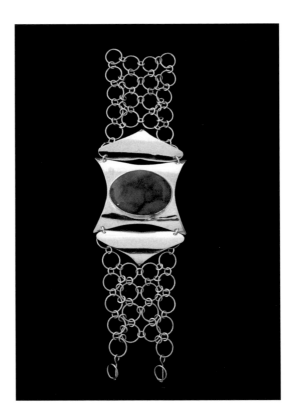

Agate chainmail bracelet, 2006, sterling silver and indian agate, bracelet: 21 x 6 cm, stone: 4 x 3 cm

tel. 01258 472100
mob. 07785 550771
email aj@fluxnflame.co.uk
web www.fluxnflame.co.uk

JESA MARSHALL

Jesa Marshall's jewellery is reflective of her fascination with the imagery of dark fairytales and magical storytelling found in illustration, animation and film.

Her designs are a fusion of precious metals and stones, which combine to create beautifully intricate but chaotic pieces, often accented with tiny cast sculptures, words and etched drawings.

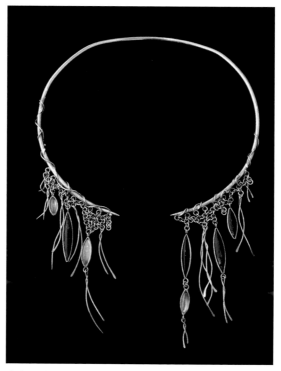

© Al Marshall

Moonstone and kyanite neck torc, 2006, sterling silver, 9ct gold, moonstones and kyanite, 21 (hanging length from back) x 16 cm

© Al Marshall

tel. 01258 472100
mob. 07785 550771
email aj@fluxnflame.co.uk
web www.fluxnflame.co.uk

VICKI MASON

Vicki Mason uses plants as metaphors in her work to represent life, death and a sense of place. Her current work references native plants from the south as well as motifs from family ceramics (Mason's Ironstone). She uses plastic for its inherent colourfulness, lucidity and formal versatility. It is a material belonging to this age, a replacement for the precious gems of more traditional eras.

© T. Bogue

Connecting whorl series, 2006, sterling silver, pvc, nylon and polyester thread, largest 4.5 x 4.5 x 1.6 cm (w x h x d)

© T. Davey

7 Hunsford Avenue, Notting Hill
3168 Melbourne
Victoria
Australia

tel. 03 9560 2249
email vickijewel@hotmail.com
web www.vickijewel.com

JO MCALLISTER

Jo McAllister uses carefully selected stones as percussive tools to achieve delicate textures in precious metals. Simple forms with glinting edges evoke memories of the deceptive qualities of desert light and landscapes. Containment and nurturing of emotion and memories is an underlying narrative. Signs of making are important, enhancing surface textures, encouraging each piece to develop its personal patina of possession.

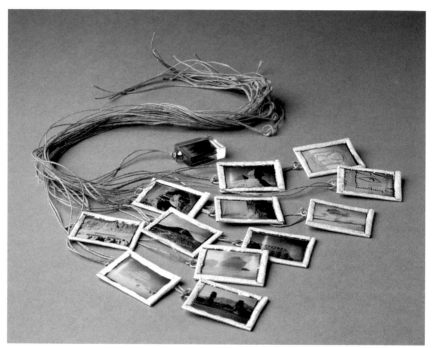

© Alexander Brattell

Tourist Tat, 2004, white precious metal, Polaroid, hemp twine and found object, 4.5 x 3.2 x 0.3 cm (w x h x d)

St. Leonards on Sea
East Sussex

tel. 01424 719900
email info@jomcallister.com
web www.jomcallister.com

Cathy McCarthy's jewellery uses organic textures and reflects the shapes and spaces to be found in natural forms. In particular she enjoys transforming metals into wearable pieces with a natural delicacy and a rich depth in surface, shape or tone. Cathy lives in Edinburgh where she has a workshop, undertakes commissions, exhibits her work and teaches jewellery making.

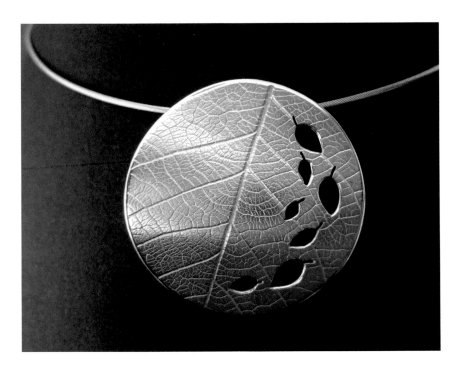

Wind swept neckpiece, 2006, sterling silver, 4.5 x 0.5 cm

tel.	**0131 229 6054**
mob.	**07719 747358**
email	**cathy.mccarthy@btopenworld.com**
web	**www.angelwingjewellery.co.uk**

VALERIE MEAD

Valerie Mead trained at Sheffield Hallam University. She makes elegant and wearable jewellery – simplicity of line is her aim. Her collection of clean-cut designs in lightly textured silver has fine contrasting details of rose-gold rivets, wires and gilding. Inspiration comes from observations of architecture and man-made objects. She also works in gold and silver to commission with individual customers.

Bracelets, 2005, silver with rose gold, each bracelet 7 cm x 0.4 cm approx.

The Workshops
15 Edith Road
Oxford OX1 4QB

tel. 01865 240809
web www.valeriemead.co.uk

Samantha Mills's jewellery conveys a personal interpretation of the relationship between object and surface, triggering memories that are personal to the wearer, and can also be recognised by others, thus challenging people's perceptions and memories of jewellery. The use of metal and textile techniques combine to give greater scope for the jewellery produced. The methods used ensure that each piece is as individual as the wearer.

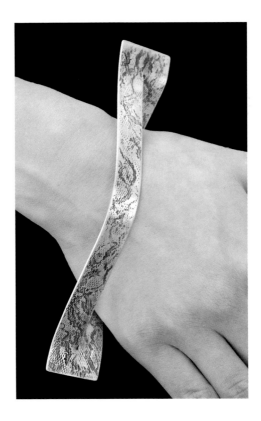

Silver lace pocket bangle, 2005, silver, 5 x 14.5 x 0.1 / 2 cm (w x h x d)

© Emma Jones

Studio 5C
Woodend Mill
Mossley
Lancashire OL5 9AY

mob. 07932 509622
email sjmillsdesigns@aol.com
web www.manchesterjewellersnetwork.co.uk

101

JANE MOORE

Jane Moore has been designing and making jewellery since graduating from Loughborough University in 1974. Her work constantly evolves and her desire to achieve fine patterns in her jewellery led her to research the design and application of fine enamel transfers. Japanese artefacts are her inspiration. She has exhibited widely in galleries such as The Electrum Gallery and Lesley Craze.

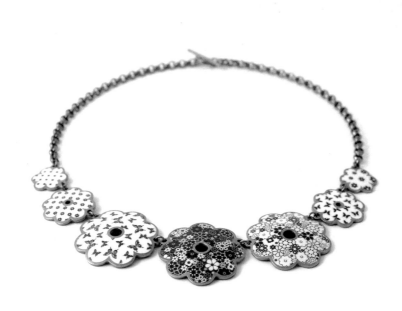

Black and white necklace, 2006, oxidised silver, enamel and enamel transfers, largest daisy 3 cm

© John Moore

16 Denby Buildings
Regent Grove
Leamington Spa
Warwickshire CV32 4NY

tel. **01926 332454**
email **jane@janemoore.co.uk**

John Moore graduated in 2002 with a degree in Three-Dimensional Design. His distinctive work can be found in various outlets around the UK and has featured in exhibitions such as Dazzle, Ruthin Craft Centre, The Scottish Gallery and Origin. Inspired by ancient artefacts and natural forms John's work explores ideas of evolution, change and rhythm, through colour and repetition.

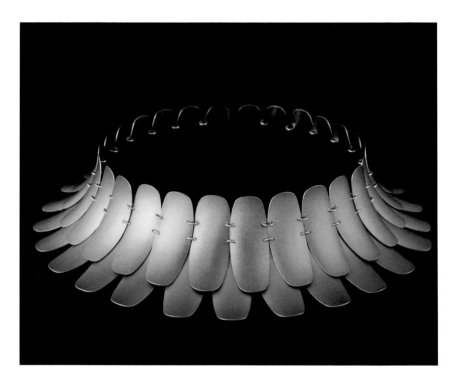

Blue-green necklace, 2006, anodised aluminium and silver, 43 x 5 cm

16 Denby Buildings
Regent Grove
Leamington Spa
Warwickshire CV32 4NY

tel. 01926 332454
email info@johnmoorejewellery.com
web www.johnmoorejewellery.com

ANNE MORGAN

Anne Morgan's current work incorporates Japanese Washi paper, which is lacquered and inlayed into silver. The paper gives the illusion of enamel with its glass-like finish. This range explores pattern and colour. Simple but strong lines are used in combination. The papers used are often one-offs and each piece is always different, even within pairs.

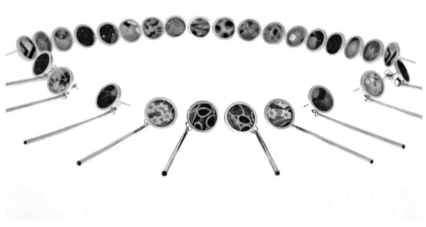

© Chris McFall

Washi studs, 2006, silver and washi paper, 1 cm diameter

10 Dryden Road
Penarth
Vale of Glamorgan CF64 2RT

tel. 02920 711918
email jewellery@annemorgan.co.uk
web www.annemorgan.co.uk

Nicola Morrison graduated from Duncan of Jordanstone, College of Art and Design in 2003 with a first class honours degree in jewellery and metalwork. Her work consists of an eclectic mix of textured components made from precious metals. The textures she creates are based on Japanese textiles. Nicola's collection of work ranges from cufflinks, bangles and neckpieces to large interlocking steel brooches.

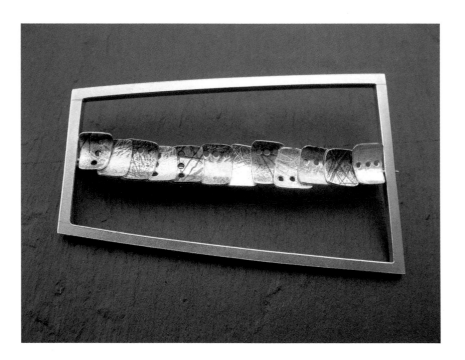

Frame brooch, 2006, silver, 22ct yellow gold and oxidised silver, 6.3 x 4 cm

mob. **07951 871657**
email **mail@nicolamorrison.co.uk**
web **www.nicolamorrison.co.uk**

DAGROW **MORVORENN**

Dagrow Morvorenn features unusual jewellery using genuine Cornish sea-glass and pottery, hand-made by Hannah Elspeth Marshall. She enjoys beachcombing around Cornwall with her Dachshund collecting treasure. Sea-glass and pottery are nasty shards of broken bottles, plates or tiles tumbled and smoothed by the sea. Each piece is securely and artistically wrapped with sterling silver or plated wire.

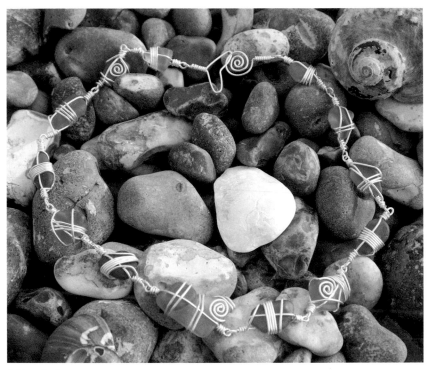

© Steven Hughes

Wire wrapped necklace, sea glass and sterling wire

© Steven Hughes

mob. **07773 564744**
email **dagrowmorvorenn@aol.com**
web **www.dagrowmorvorenn.com**

KATHIE MURPHY

Kathie Murphy started evening classes at the age of 14 and then went on to gain a degree in jewellery from Middlesex Polytechnic and a post-graduate diploma from Glasgow School of Art. A practicing jeweller ever since, she has specialised in pieces made from polyester resin and written a book titled *Resin Jewellery*, published by A&C Black.

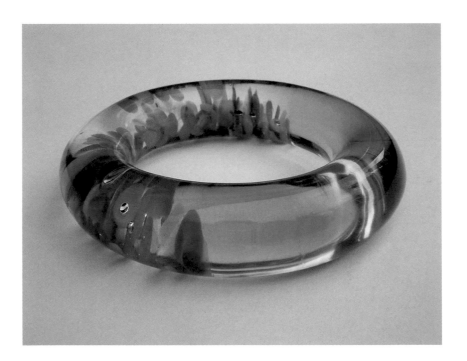

Resin bangle, 2006, polyester resin, 10 cm diameter approx.

mob. 07973 249852
email kathie-m@dircon.co.uk

MANDY NASH

Mandy Nash started her jewellery business after leaving the Royal College of Art in 1983, mostly working in anodised aluminium but more recently also in felt. Colour and pattern provide constant inspiration: designs are triggered by memories of journeys and experiences. Her grandmothers initiated her creative path by passing on their traditional textile skills, sparking her passion for using colourful materials.

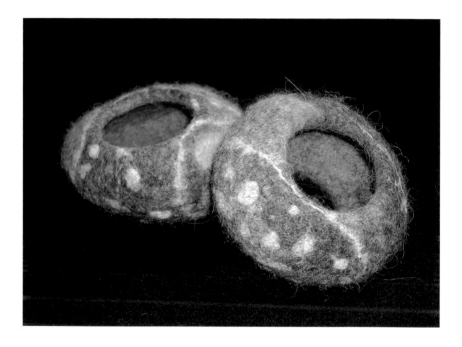

Bangles, 2006, felt, 13 x 6 cm each approx.

Model House Craft & Design Centre
Bull Ring
Llantrisant
RCT CF72 8EB

tel. 01443 229333
email mandynash@craftinwales.com

April Neate is fascinated by architecture. She 'collects' architectural details with her camera and is drawn to lettering and numbers on buildings, as well as doorways, keyholes and patterns. She translates these ideas into jewellery using presswork to create hollow forms, and photo-etching to 'draw' on the surface of the metal. She is currently experimenting with new ideas in anodised aluminium.

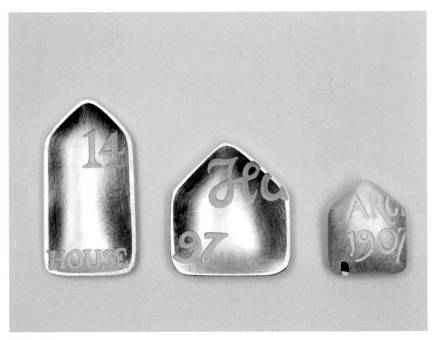

© Richard Neate

Tall house brooch: 'House 14', House brooch: 'London shopfront' Small Pillow house pendant: 'Built in 1907', 2006, silver, from left to right (w x h x d): 1.9 x 3.7 x 0.4 cm, 2.3 x 2.6 x 0.4 cm, 1.6 x 2 x 1.9 cm

71 Vyse Street
Hockley
Birmingham B18 6EX

email april@aprilneate.com
web www.aprilneate.com

CATHY NEWELL PRICE

Cathy Newell Price's intricate one-off pieces often tell a story: the escape of nature, the changing of the seasons. Almost always a common theme is the natural world which is not surprising as Cathy's degree was in Plant Science. Elements of these special pieces are developed into her ranges of jewellery. Colour is introduced to silver pieces with semi-precious stones, enamel, and gold.

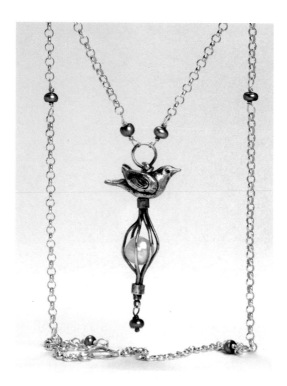

© James Newell

Freed bird necklace, 2004, silver and pearls, pendant 6.5 x 2.7 cm

tel.	**0118 926 1494**
mob.	**07906 434680**
email	**cathynewellprice@yahoo.co.uk**
web	**www.cathynewellprice.co.uk**

Gill Newton's philosophy of jewellery is uncomplicated. She makes each piece by hand using natural lines and forms informed by drawing to lend her work sculptural qualities. Often she will leave a trace of the hammer marks or a soldered join to distinguish it from mass production. Gill wants her work to be touched, worn and enjoyed.

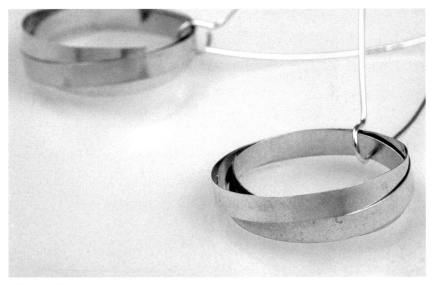

© Electronic Marketsquares

Mobile wrap earrings, 2005, sterling silver sheet and wire, sheet: 0.3 cm, wire: 3 x 7 x 0.9 cm
(w x h x d), total length 10 cm

© B. Donovan

31 Victoria Road
Guildford
Surrey GU1 4DJ

mob. 07739 166737
email gill.newton@fsmail.net
web www.axisweb.org/artist/gillnewton

HELEN NOAKES

Helen Noakes adores surprises….and it shows! Hard-to-find miniature figures are the focus of her resin range and run the gamut from penguins and terriers to cheeky punk rockers, belle epoque swimmers and nude bathers. Clever designs include swimmers gliding around a resin and silver cuff, pendants with sheep grazing in green-dyed resin and deliciously irreverent "Nun" necklaces.

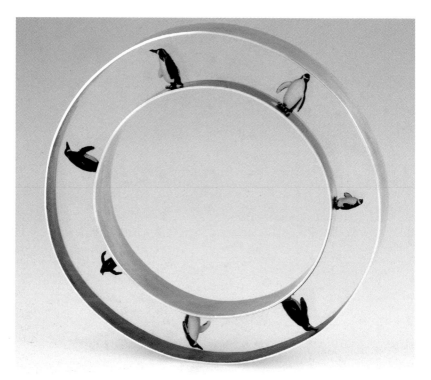

© Electronic Marketsquares

Penguin march bangle, 2005, silver, epoxy resin and plastic, 1 cm wide x 9.5 cm outer diameter x 6.5 cm inner diameter

13 Albany Terrace
Wilton
Salisbury
Wiltshire SP2 0HF

tel. **01722 743141**
email helennoakes@mac.com
web www.helennoakesjewellery.com

KRYSTYNA NOWICKA

Krystyna Nowicka is a 2004 BDes (Hons) Jewellery and Metal Design graduate from Duncan of Jordanstone College of Art and Design, part of the University of Dundee. She has a workshop in WASPS Studios, Meadow Mill. Currently her inspirations are derived from nature's structure and form. Silver, gold and gold-plate are her main materials used. She also uses hand-engraving to add surface texture to her pieces.

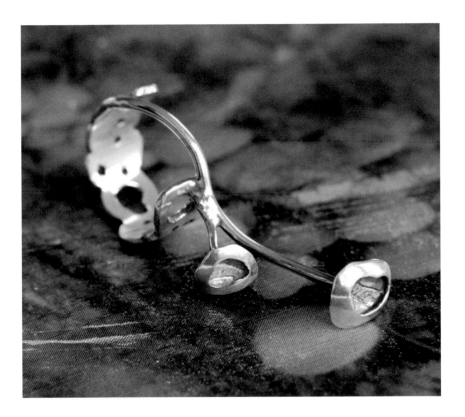

Tendril ring, 2006, sterling silver and 18ct gold plate, 4.5 cm long, band 1 cm wide, size L

mob. **07763 137007**
email **clearopal@hotmail.com**
web **www.krystynanowicka.co.uk**

HAROLD O'CONNOR

Harold O'Connor's designs are inspired from his environment, travel to exotic countries and observing various aspects of society. In his creations one will find the use of pictorial and abstract form. Harold is interested in the essence of a material – not its intrinsic value. He enjoys integrating classical techniques into contemporary forms.

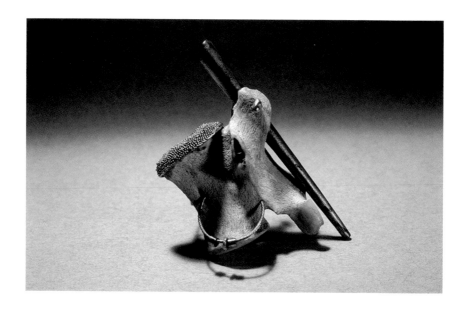

Hunting season brooch, 1997, elk bone, 24ct gold, 18ct gold and silver, 6.5 x 7 cm

P.O. Box 416
Salida
Colorado
81201 USA

tel. 719 539 7519
email dunconor@yahoo.com
web www.haroldoconnor.com

Peter Page, designer and goldsmith, creates jewellery that reflects the desires and individual character of his clients. His work has been commissioned, collected and exhibited worldwide and has featured in many publications. Designing and making on commission, primarily in 18-carat gold and platinum, he often uses diamonds and other gemstones and, in his work, he recognises his clients individuality, creating jewellery that is very personal to them.

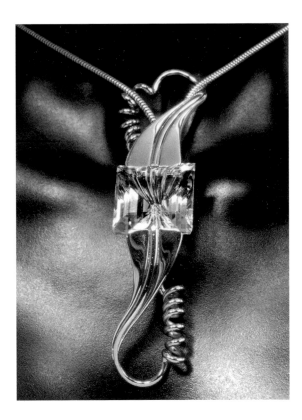

Venetian pendant, 2004, 18ct yellow and white gold and blue topaz, 8 x 3 cm

© Llewelyn Robins

tel. **01672 520428**
email **peterpagegoldsmith@tiscali.co.uk**
web **www.peterpage.co.uk**

GUEN PALMER

Guen Palmer is a graduate of Central St Martin's and now works from her Cotswold studio designing and making distinctive contemporary jewellery that is entirely produced by hand, using traditional techniques. Inspired by the beauty of the materials she works with, she strives to design affordable pieces of jewellery that have a close relationship with the wearer, enjoying the restrictions and challenges this imposes.

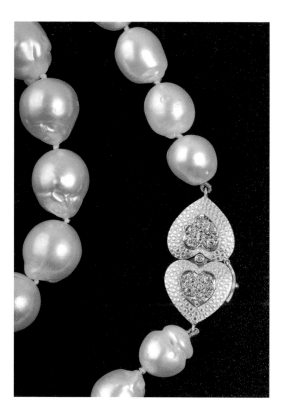

18ct gold and diamond necklace clasp, 2004, 18ct gold, diamonds and South Sea pearls

© Haddon Davies

Oxfordshire

tel. **01608 659703**
email **info@guenpalmer.com**
web **www.guenpalmer.com**

Chris Pate studied at Bristol School of Art where she explored combining the contemporary medium Precious Metal Clay with traditional jewellery techniques. PMC now forms an integral part of her work, providing the sculptural, textural and three-dimensional qualities she desires. Her inspiration comes from life experiences and memories. She designs and makes from her studio in Somerset and runs courses on PMC.

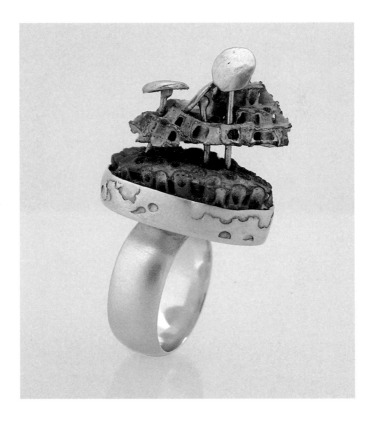

A walk on the beach – part 1 of series 3, 2006, silver, gold, pmc and coral, 2.5 x 4.5 cm

tel. **01275 331041**
email **enquiries@touchmark.co.uk**

SUILVEN PLAZALSKA

Suilven Plazalska's work is strongly concept based, using plastics alongside silver and gold. After graduating from the Glasgow School of Art (GSA) in 2001, she spent one year as Artist in Residence at the GSoA before establishing her studio at WASPS, Glasgow. Suilven is a regular visiting lecturer for the GSoA and works as a freelance arts tutor throughout Scotland.

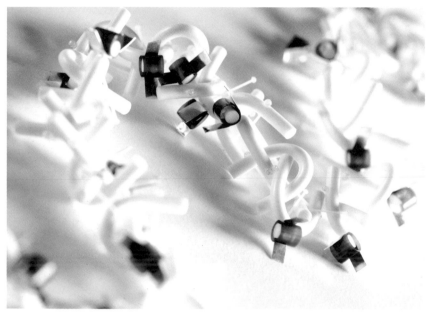

© Shannon Tofts

Space invader (neckpiece), 2006, polypropylene plastic, silicone rubber, plastic drinking straws, silver and fine silver, 2 x 35 cm

© Suilven Plazalska

Studio 206, WASPS Artists Studios
77 Hanson Street
Glasgow G31 2HF

mob. **07855 677826**
email **info@suilvenplazalska.com**
web **www.suilvenplazalska.com**

Jo Pond's work originates from a passion for old and discarded objects and a drive to create harmonious compositions. She constructs narrative content by utilising unusual materials and unconventional objects, being interested in the ambivalent perceptions of personal beauty and their consequential relationship to confidence, self-value and psychological health. Her aesthetic inspiration develops from the unintended details found in decomposition and changing materials.

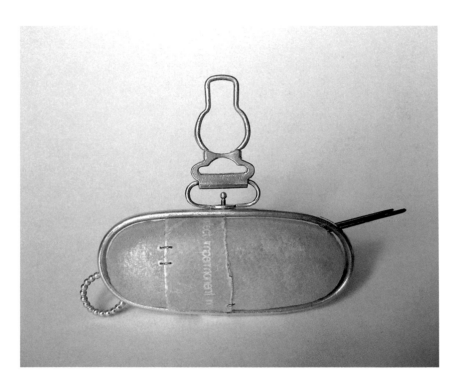

Distraction brooch, 2005, silver, vellum, 18ct gold and needles, 8.7 x 6.2 cm

Hemington
Derby
DE74 2RB

tel. **01332 696810**
mob. **07890 448174**
email **jo@jopond.com**
web **www.jopond.com**

DIANA **PORTER**

Diana Porter went to university after a varied working life in teaching, arts administration and theatre, and emerged in 1993 with a BA (Hons) in Jewellery. Her jewellery is a synthesis of her creativity along with her personal and political beliefs. She draws on ancient shapes and traditions of female power and is famous for her use of words as decoration.

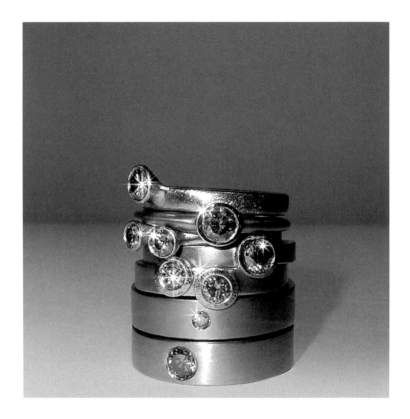

Chocolate diamond rings stack, 2007, 18ct white gold with chocolate diamonds, 9.75 x 14.05 cm

33 Park Street
Bristol
BS1 5NH

tel. 0117 909 0225
email post@dianaporter.co.uk
web www.dianaporter.co.uk

Suzanne **Potter**'s decorative and elegant jewellery intuitively explores and celebrates universally found formulaic geometric structures, observed throughout natural and mechanical worlds, echoing her immediate rural environs. Rhythmic daisy chains, graphic statement brooches, sculptural rings – all illustrate the maker's voice and aesthetic, inviting the onlooker to be included, either physically via the senses, play, interaction, wearing of, or emotionally, by identifying and evoking familiar, happy memories, themes and objects.

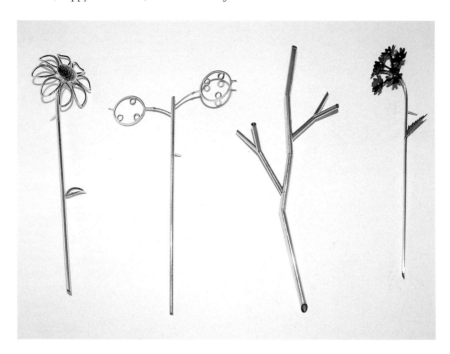

Daisy, Honesty, Branch: Stripped Bare and Verbena Stem brooches, 2005, white metal and oxidised details, from left to right (w x h x d): 4 x 14.8 x 3 cm, 8.6 x 13.6 x 1.6 cm, 6 x 16 x 2 cm, 3 x 14 x 3.5 cm

Glen Esk
Wycombe Road
Stokenchurch
Bucks HP14 3RQ

tel. 01494 484261
email enquiries@suzannepotter.co.uk
web www.suzannepotter.co.uk

QUAY PROCTOR-MEARS

Quay Proctor-Mears was born in Cleveland, Ohio where she worked at the Cleveland Museum of Art before travelling in Europe, the Middle East and Africa throughout the 1970s. As co-founder of the Made in Clay group in the early 1980s, Quay cites the local pebble beaches and 'big skies' as influencing her work, which is constructed in a simple and clear style.

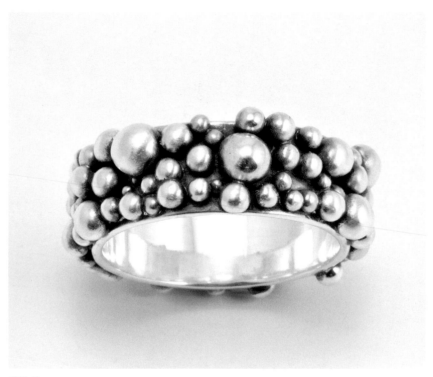

© W. Altmann

Pebble ring, 2006, silver, red gold, white gold and yellow gold

© W. Altmann

Made in Cley
High Street
Cley-next-the-Sea
Norfolk NR25 7RF

tel. 01263 740134
email quay113@aol.com
web www.madeincley.co.uk

PRUDEN & SMITH

Pruden & Smith specialise in designing and making precious jewellery and silverware. Their unique design training and 20 years of craftsmanship experience ensure the very best in contemporary design. Work in platinum, diamonds, gold and silver can be purchased, commissioned or simply admired in their Ditchling gallery.

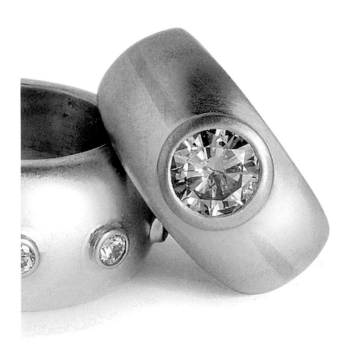

© Gema Designs

Silver ring with 22ct gold inlay, 1.5ct round brilliant cut diamond, 2006, silver, 22ct gold and diamond, weight: 19 gm, 1 x 0.4 cm, size P

2 South Street
Ditchling
East Sussex BN6 8UQ

tel. 01273 846338
email info@silversmiths.co.uk
web www.prudenandsmith.com

MARTYN PUGH

Martyn Pugh's inspiration is rooted in the purity of natural form and the geometry of engineering and architecture. Using precious metals, either individually or in combination, he produces subtle forms of understated elegance. Stones are used as an integral part of the form using subtle setting techniques. The wearer's spirit and individuality are reflected in pieces made to commission.

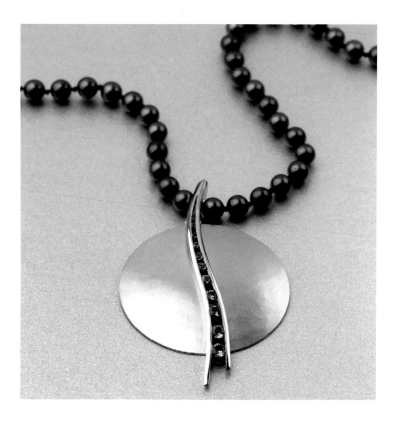

'Art' 'Night' pendant, 2006, Palladium, pink sapphires and black pearls, 4 cm diameter

8 Winyates Craft Centre
Winyates
Redditch
Worcestershire B98 0NR

tel. 01527 502513
email martyn@martynpugh.co.uk
web www.martynpugh.co.uk

Eve Redmond divides her time between her studio at Manchester Craft & Design Centre and City College where she is Course Leader in Jewellery. Her work reflects contemporary lifestyle and merges individuality with function. She is inspired by kinetics, sculpture and architectural forms and loves creating one-off pieces for exhibitions where she can blur the boundaries between traditional and Fine Art approaches.

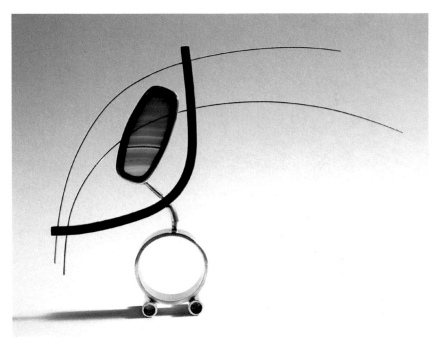

© Edward Chadwick

Ring, 2004, silver, steel and agate, 12 x 12 cm approx.

Divinity Gallery, Studio 22
Manchester Craft & Design Centre
17 Oak Street
Manchester M4 5JD

tel. 0161 834 2994
email redmondeve@yahoo.com
web www.everedmond.com

KATHLEEN ELLEN **REEVES**

Kathleen Reeves came to enamel and metal late, after a career as a broadcast graphic designer for the BBC. Line, narrative and observation of natural form play an important role within her work, which she is currently expanding with an MA in Fine Art Research. Group exhibitions include Rising Stars, recent graduates in enamel: Studio Fusion Gallery, London 2006.

© Jason Ingram

Hand image brooch, 2006, wet process enamel on brass, 10 x 3.5 cm

Powdermill Farm
Littleton Lane
Winford
North Somerset BS40 8HE

tel. 01275 333620
email kathleenreeves@tantraweb.co.uk
web www.touchmark.co.uk

Loukia Richards is a Berlin educated designer and painter, inspired by neolithic figurines and cuneiforms. She works with textile, a material of sacred character in her hellenic heritage. Her jewellery is a game of inventing something precious in form and meaning from an unexpected material. Private collectors of her work include: The Onassis Benefit Foundation, New York and The Peloponnesean Folklore Foundation, Greece.

© Studio Kominis, Athens

Cycladic cross, 2000, silk, semi-precious stones, vintage button, silk and cotton threads, 52 x 5.5 cm

14 Zaimi Str.
10683 Athens Greece

tel. **0030 210 381 2211**
tel. **0030 6974 022850**
email **loukiarichards@yahoo.com**
web **www.photostore.org.uk/
 secvpg.aspx?mid=112833**

© Studio Kominis, Athens

KERRY RICHARDSON

Kerry Richardson creates African inspired jewellery in her three ranges. She uses precious metals and stones, and combines non-precious materials and lustres in her 'Keramika' range. Her recent work is focused on versatility and component combinations to offer greater flexibility and affordability. She is interested in recycling old jewellery and works to commission as well as exhibiting her work nationally and internationally.

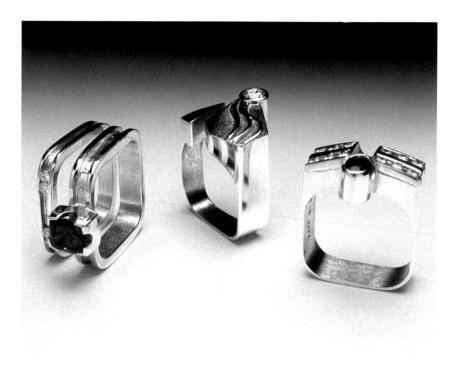

© Joel Degen

Addables ring, 2004, 18ct and diamonds

Studio 78
Linnet
Orton Wistow
Peterborough PE2 6XZ

tel. 01733 238699
web www.kerryrichardson.com

Melissa Rigby has won many awards for her innovative jewellery designs and exquisite enamelling since graduating in 2002 from Guildhall University (now LMU). She draws inspiration from modern architecture and nature, and produces hand-crafted jewellery collections in a variety of different materials, from enamelled precious metals and stones to modern plastics. She exhibits nationally as well as making to commission.

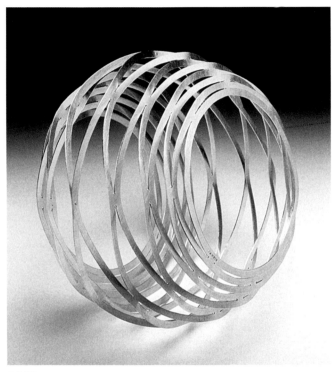

© Joël Degen

Expandable Halo bangle, 2002, sterling silver, 0.01-7.5 x 11.5 cm

London N5

tel. 020 7359 3591
email rigbymelissa@hotmail.com
web www.enamellers.org

ZOE ROBERTSON

Zoe Robertson has established her business "thedesigndiva.com" since graduating. Excited by the tactile qualities of materials her work explores the relationship between surface texture and magnetic three-dimensional forms.
Currently she is secretary for the ACJ Midlands regional group and also a full-time lecturer on the BA (Hons) Jewellery and Silversmithing course at the School of Jewellery, UCE Birmingham.

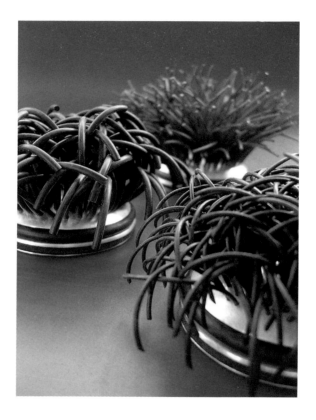

Magnetic brooches, 2006, rubber, magnets and silver plated base metal, 5 x 5 cm approx.

Birmingham
UK

mob. 07796 037569
email diva@thedesigndiva.com
web www.thedesigndiva.com

Kayo Saito creates sculptural jewellery using non-precious and precious materials. Polyester fibre has allowed her to achieve an extremely delicate-looking quality in her work, resulting in light-weight but very durable pieces. Lately, she has transposed her work to metal in the shape of gold and silver pieces that emulate the fragility of fibre.

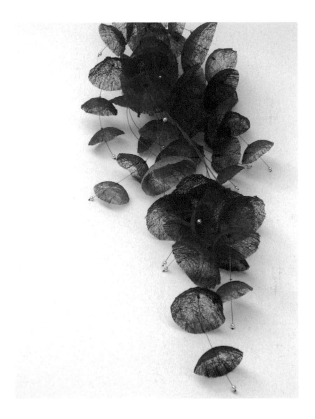

Summer flower, 2005, polyester fibre and freshwater pearls, 50 cm approx.

mob. **07976 615712**
email **info@kayosaito.com**
web **www.kayosaito.com**

MARIA **SALOMON**

Maria Salomon was born in Argentina in 1968, but has lived in Europe since 1989, where she started making jewellery. In 1997 she came to live Portugal and there she started making jewellery using aluminium wire and a range of beads, from glass to semi-precious stones. She also designs and manufactures jewellery for brides as a special sideline. Always keeping abreast of fashion trends, she intends one day to teach future artisans.

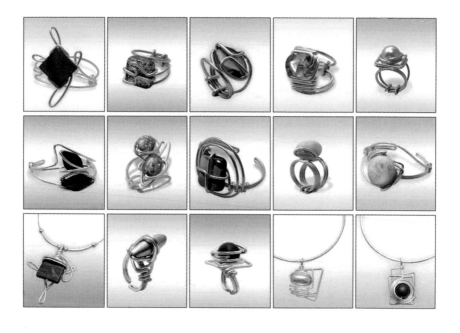

Faith, 2006, aluminium and acrylic beads, pendant 5 x 5 cm

Portimão
Portugal

tel. 00351 965 594203
email mariasalomon@netcabo.pt
web www.shukram.com

Tamizan Savill set up her workshop in 2001, winning an award from ACE SW the next year. She used to build recording studios for young people, but enamelling is much quieter. Commissions include badges of office for Bristol Cathedral and Bristol Museum & Art Gallery. She works with vitreous enamels on silver and gold, in *champlevé* and subtly shaded *basse taille*.

8 enamelled rings, 2005-2006, silver and vitreous enamels, 1-1.3 cm wide

tel. **0117 966 0107**
email **tamizan@bigfoot.com**
web **www.tamizan.com**

CLAIRE SCAWN

Claire Scawn graduated from the University of Wales Institute, Cardiff with a first class honours degree in Ceramics. With her history in jewellery she now fuses the two together, creating sculptural pieces that exist both within the home and upon the body. This has become the signature within which her work will be recognised.

© Mal (UWIC)

Intimacy - brooch, 2006, porcelain and silver, stage: 23 x 16 cm, box: 9 cm diameter, brooch: 6 cm diameter, pin: 12 cm long

Broad Street Studio
35 Broad Street
Blaenavon
Torfaen NP4 9JS

tel. 01495 792786
email clairescawn@makersconnect.com
web www.makersconnect.com

Sarah Scott's route to jewellery making was through textiles, paper and fibre arts. Abstract shapes and patterns are important but texture is especially significant in her work. Influenced by ancient treasure hoards and the effects of age on metal, she uses patination, burnishing, hammering and (con)fusion to create the pieces which include earrings, neck chains, brooches and bracelets.

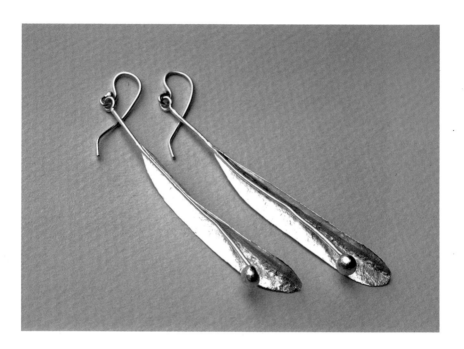

Linden earrings, 2006, silver, 7 x 1.5 cm

Devon

tel. **01392 841250**
email **sarah@sarahscottjewellery.co.uk**
web **www.sarahscottjewellery.co.uk**

JEAN SCOTT-MONCRIEFF

Jean Scott-Moncrieff trained in typography and worked principally as a graphic designer before establishing her jewellery studio at the turn of the 21st century. Influenced by ancient cultures she designs and makes jewellery in silver and high-carat gold. Her work is characterised by simple, bold forms with subtle surface textures and unusual gemstones.

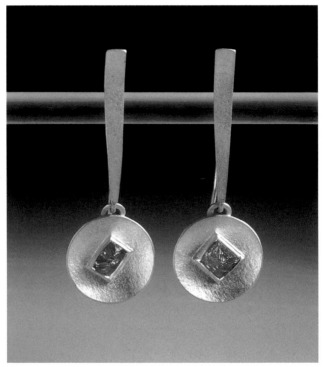

© FXP

22ct gold earrings with natural octahedral diamonds, 2006, 4 cm drop

© Harriet Medvei

78 Fentiman Road
London SW8 1LA

tel. 020 7735 0009
email jean@jeanscott-moncrieff.co.uk
web www.jeanscott-moncrieff.co.uk

GEMMA SCULLY

Gemma Scully completed a degree in Jewellery and Metalwork BA (Hons) at University College for the Creative Arts in Farnham. Before starting the third year she completed an Artist in Residency. This time helped focus her work towards Conceptual Jewellery; she now tackles socio-political issues within society. One of her latest collections focuses on the growing number of teenagers self-harming.

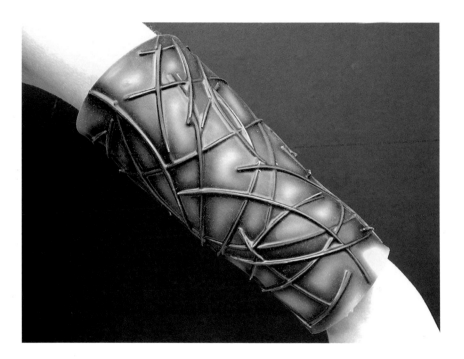

Armpiece, 2006, liquid latex and copper wire, 35 x 0.5 x 25 cm (w x h x d)

21 Moorfield Avenue
Stalybridge
Cheshire

mob. 07795 523932
email scully@zoom.co.uk
web www.gemmascully.co.uk

EMMA SEDMAN

Emma Sedman's distinctive jewellery designs evolve from her passion for colour and use of transparent enamels for their depth and luminosity. Each piece is individually created and current collections incorporate single enamel colours with variations of gold and silver leaf. These additions of intriguing seams of precious metal leaf add another dimension to the strikingly simple designs.

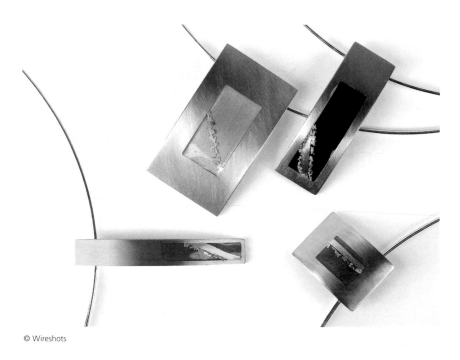

© Wireshots

Elipse pendants, 2005, silver, enamel and precious metal leaf, from 0.6 x 3.8 cm to 1.8 x 3.5 cm

© Emma Sedman

tel. **01969 620021**
email **emma@emmasedman.co.uk**
web **www.emmasedman.co.uk**

ERICA **SHARPE**

Erica Sharpe's lifetime's quest for technical perfection has led her to study with an Indian master goldsmith, master ancient Etruscan techniques and work with a range of leading figures of modern jewellery. Combining exceptional craftsmanship with a delight in the qualities of gold, platinum and gemstones, Erica's work is suffused with light and meaning: 'Not the image of a swallow but its flight on a summer's evening'.

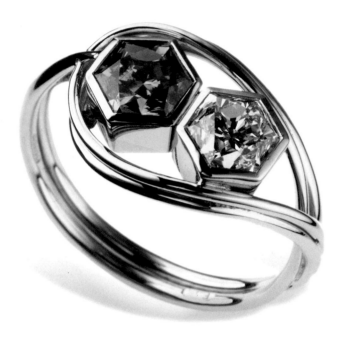

© Adrian Burke

Honey bee dance, 2006, ring in 18ct yellow gold, platinium and natural coloured diamonds, 2.5 x 1.2 cm

8 Borough Mall
Wedmore
Somerset BS28 4EB

tel. **01934 710448**
email info@ericasharpe.co.uk
web www.ericasharpe.co.uk

139

SASKIA **SHUTT**

Saskia Shutt's jewellery boasts a comprehensive range of neckpieces shaped to fit the neck, bangles, rings, earrings, pendants and cufflinks. Designs are derived from crisp lines and flowing curves, creating simplistic pieces in a sophisticated style. Pieces are in solid silver or gold, often with one contrasting surface in a textured finish sometimes set with semi-precious stones. Saskia welcomes commissions.

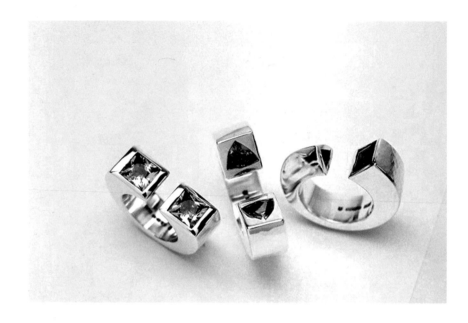

Chunky ring, 2002, silver, aqua's, peridots and Iolites, 1.1 cm x 0.8–0.3 cm

10 Cornfield Lane
Eastbourne
BN21 4NE

mob. **07939 722040**
email **saskiashutt@aol.com**
web **www.saskiashutt.com**

Dot Sim is inspired by her rural Scottish environment – starry skies, changing land-scapes, stormy seas. Movement of line and tactility are strong features, and some pieces are contained by free-blown glass vessels.

She uses materials that stand the test of time, as she is interested in the role of jewellery as heirloom, providing memories for future generations.

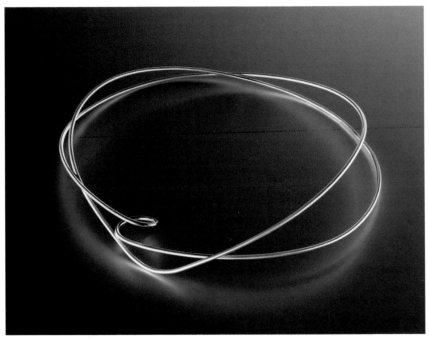

© Victor Albrow

Neckpiece, 2005, silver, 25 cm diameter

© Brodie Sim

Scotland

tel. **01382 553409**
email **dot@dotdotsim.com**
web **www.dotdotsim.com**

HEATHER M SKOWOOD

Heather Skowood is interested in building forms that relate closely to the area of the body and the space around it where it will be worn. This means that one can see architectural and sculptural influences in her work. She desires the wearer of her jewellery to be aware of the piece, how it effects their movement, their view of themselves and those around them and to appreciate beauty from unexpected places.

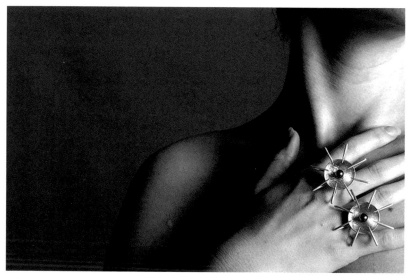

© Jonathan Keenan Photography

'Strangeways we have arrived' knuckleduster, 2006, sterling silver and black pearls, 9 x 5.5 x 4.5 cm (w x h x d)

© Jonathan Keenan Photography

email info@heatherskowood.com
web www.heatherskowood.com

LAILA SMITH

Laila Smith has been working as a jeweller since graduating 10 years ago, and teaching jewellery and metalwork for seven years. Her work explores ideas of stitch as a contemplative process, and the medium of textile as one that can bring its own history to the work. The jewellery references traditional jewellery forms, but is not bound by traditional materials.

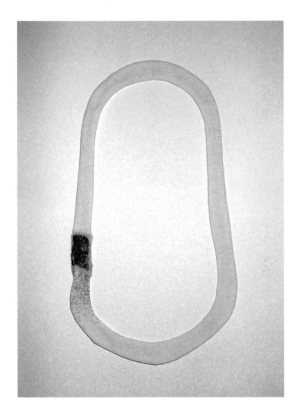

'Not waving', 2006, linen, thread and family textiles

Cross Street Studios
14 Cross Street
Hove
East Sussex BN3 3GP

tel. 01273 725321
email smithlaila@hotmail.com
web www.crossstreetworkshop.co.uk

SUZANNE SMITH

Suzanne Smith's work is inspired by the tradition of taking afternoon tea, with the food consumed and the tableware used in this ritual providing a varied source of colour, texture and pattern. Using a variety of materials such as handmade felt, hand-dyed vintage lace, gemstones and precious metals, she creates quirky, contemporary jewellery and decorative objects.

© Brian Fischbacher

Decorative chocolates, 2006, handmade felt, lace, precious metal and paper

mob. **07855 342127**
email **hello@suzannesmithdesign.co.uk**
web **www.suzannesmithdesign.co.uk**

Lucy Sylvester has completed her MA in Jewellery and Silversmithing and now works from her Oxfordshire studio. She is drawn to the preservation of natural forms, saving the delicate seedheads and insects from the effects of time, and also the twisted pleasure of a woman being adorned by the insects she would no doubt swot in everyday life.

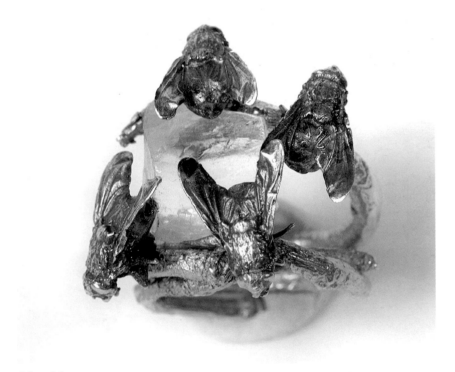

© Simon Fuller

Aquamarine and fly ring, 2004, silver and uncut aquamarine, 1.5 x 4 x 3 cm (w x h x d)

© Elly Crook

Studio 15
15a South Street
Banbury
Oxon OX16 3LB

tel. 01295 263848
email mail@lucysylvester.co.uk
web www.lucysylvester.com

HUIYI **TAN**

Huiyi Tan has an architectural background and is fascinated with abstract forms. Lines and surfaces are the interesting points of her structural objects; composition in abstract form is the theme of her work. Because of the open visible space, she chooses rings as her practice and research objects.

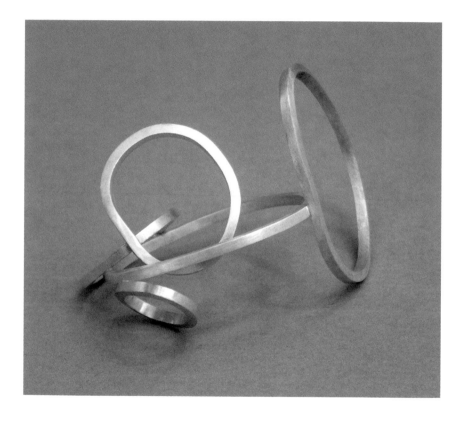

Ring 1–5, 2005, sterling silver, 6 x 5 x 4 cm (w x h x d)

email mail@huiyitan.com
web www.huiyitan.com

MARI THOMAS

Mari Thomas is an award winning designer jeweller. Working in precious metals and diamonds her contemporary designs are influenced by Welsh culture and often include the written word. She creates wearable pieces of art to adorn the body by layering and fusing metal, sometimes highlighted with a solitaire stone. Her jewellery is exhibited nationally and internationally, with several distinctive collections, and commissioned works.

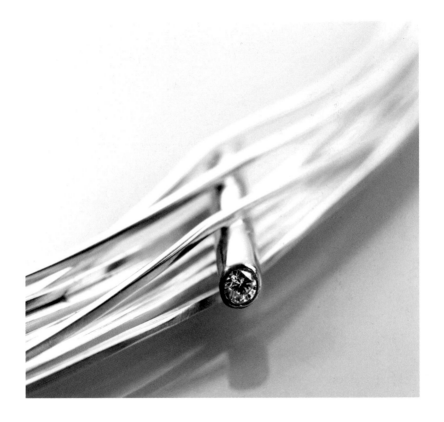

Solitare, 2007, silver and diamond

© Mari Thomas

51a Penllwyngwyn Road
Bryn
LLanelli, S. Wales
SA14 9UH

tel. **01554 821227**
email **info@marithomas.com**
web **www.marithomas.com**

GUN THOR

Gun Thor was born and educated in Sweden. She moved to England in the 1960s and later studied Jewellery and Enamelling at Sir John Cass School of Art, London, finishing her Extended Studies course in 1979. Since 1980 Gun Thor has run her own workshop studio in London, producing one-of-a-kind pieces as well as studio multiples.

© Joel Degen

Three bracelets, 2006, sterling silver, 8.5 cm diameter

2 Boscastle Road
London NW5 1EG

tel. 020 7267 0842
email gun.thor@neurath.co.uk

Jonquil Tonge graduated from Birmingham University with a BA in Jewellery, Silversmithing and Design. She then worked in the city's Jewellery Quarter before developing her own range. She has created colourful felt jewellery and is now working on spirals, waves and circles incorporating silver and agate beads which give elements of movement and fun. Jonquil also teaches jewellery at Havant and Hayling Island, Hampshire.

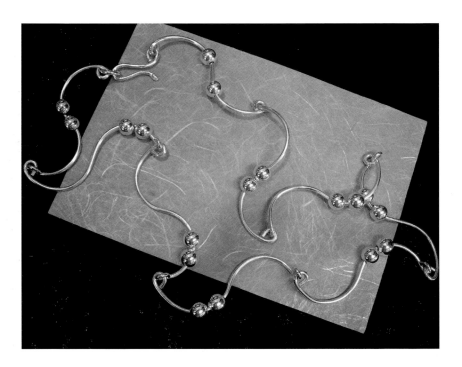

Wavy necklace with silver beads, 2006, silver

14 Whichers Gate Road
Rowlands Castle
Hampshire PO9 6BB

tel. 02392 413871
email jonquil.tonge@btinternet.com

EMMA **TURPIN**

Emma Turpin graduated from Middlesex University in 2005, with a BA (Hons) in Jewellery. Since then she has taken part in New Designers and the Getting Started course at Goldsmiths. Her work is inspired by a traditional British craft called 'Maidens Garlands'. Emma has developed this craft into unique pieces of jewellery in silver and gold with elements of oxidisation.

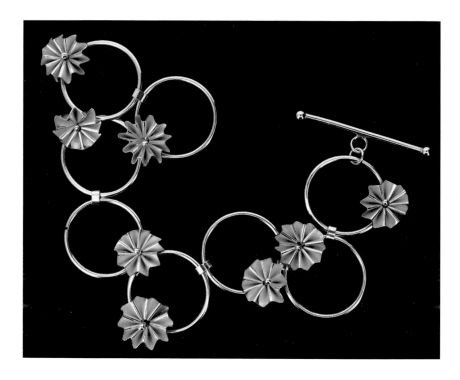

Rosette bracelet, 2006, silver, 17 x 2.5 cm

mob. **07860 749299**
email **emma_turpin8@hotmail.com**
web **www.emmaturpin.com**

Elizabeth **Turrell**'s enamel work is inspired by memorials and markers which celebrate the lives of ordinary citizens caught up in the extraordinary circumstances of conflict and war. The panels include fragments of text from the Universal Declaration of Human Rights. She feels compelled to make these markers and memorials, both to remember individuals and to mark conflict.

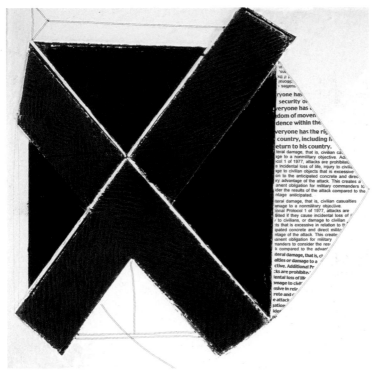

© Colin Somerset

Universal declaration of human rights series, 2006, vitreous enamel on steel and enamel transfer (detail), 30 x 30 x 2 cm (w x h x d)

© Mark Simmons

email Elizabeth.Turrell@uwe.ac.uk
web www.studiofusiongallery.co.uk

JESSICA **TURRELL**

Jessica Turrell has developed a range of etching and enamel techniques through which she explores her interest in obscured and degraded text and imagery, and in repetitive mark-making. The processes used alternately conceal and reveal marks and images on the surface of the work. Jessica endeavours to use enamel in a way that imbues her jewellery with a tactile delicacy and an ambiguous surface quality.

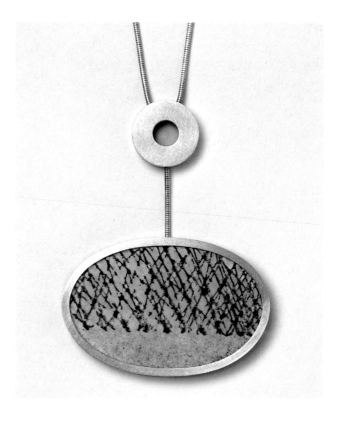

Neckpiece, 2006, silver, copper and enamel, pendant size 5 x 3.2 cm (overall length 54 cm)

Bristol
U.K.

tel. 0117 966 0749
email jessica@jpjhome.freeserve.co.uk

SYANN **VAN NIFTRIK**

Drawing freely from her environment without being representational, she keeps the processes simple, leaving room for her subconscious to take hold in the hope that others can in turn indulge their imagination. It is the possibilities inherent in the materials and the making process that interest van Niftrik and this remains discernible in the work.

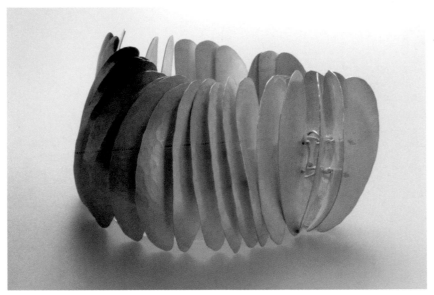

© Nick Barberton

Leaf fall bracelet, 2005, silver, 19 x 7.4 cm

The Cottage
Woodgreen
Fordingbridge
Hants SP6 2AR

tel. 01725 510364
email vanniftrik@hotmail.com

SALLY WAKELIN

Sally Wakelin's designs are dominated by geometry; she explores the complexities of juxtaposing apparently simple forms using repetition and articulation to create very modern wearable pieces in sterling silver. Often using mathematical forms as a starting point Sally makes jewellery varying from complex delicate structures to large and bold forms.

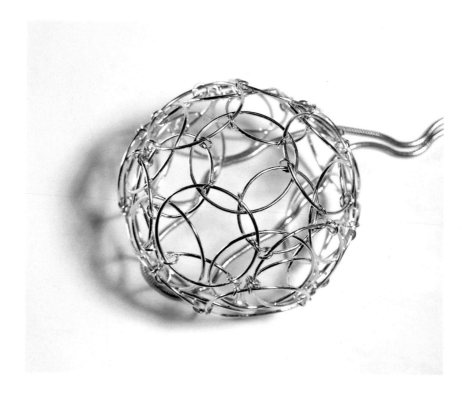

Geodesic dome pendant, 2006, sterling silver, 9 cm diameter open, 5 cm diameter closed

London

tel. **020 8318 4296**
email **info@sallywakelin.co.uk**
web **www.sallywakelin.co.uk**

HELEN **WALKER**

Helen Brice graduated from Herefordshire College of Art & Design in 1999 with a BA (Hons) in Design Crafts. Her jewellery ranges have evolved from a fascination with architectural details such as brightly painted ceramic tiles, coloured glass and vivid, naturally occurring palettes, such as flowers and earth pigments. She now works predominantly in sterling silver inlaid with colourful resins.

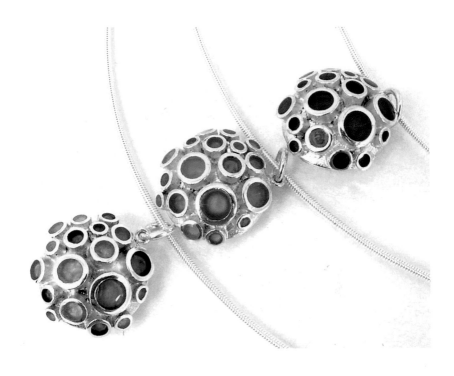

Bubbles pendants on choker wire, 2005, sterling silver, cold enamel and resin, pendants approx 1.6 cm diameter

40 Cotterell Street
Hereford HR4 0HQ

tel. 01432 263209
email helenbrice@aol.com
web www.helenbrice.co.uk

155

JENNY WALKER

Jenny Walker finds a wealth of precious content in the ordinary objects she collects. Here she incorporates Victorian ceramic fragments found in Manchester. They are a link to the city's past inhabitants through the remnants of the everyday items they once used. This connection to person and place through the found object is a never-ending source of inspiration.

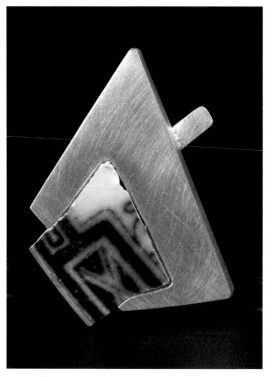

© Tony Richards

Blue edge ring, 2006, fine silver and victorian ceramic fragment

© Tas Kyprianon

mob. 07734 430760
email jennywalker@contemporary
jewellery.freeserve.co.uk

Katharine Warner trained at UCE Birmingham for a BA (Hons) in Jewellery and Silversmithing and at Edinburgh College of Art for a Postgraduate Diploma in Jewellery. Since graduating in 2000 she has exhibited regularly at specialist galleries and exhibitions. Katharine is fascinated by intricate techniques, her jewellery is always of a tactile nature, not only interesting to touch but luxurious to wear.

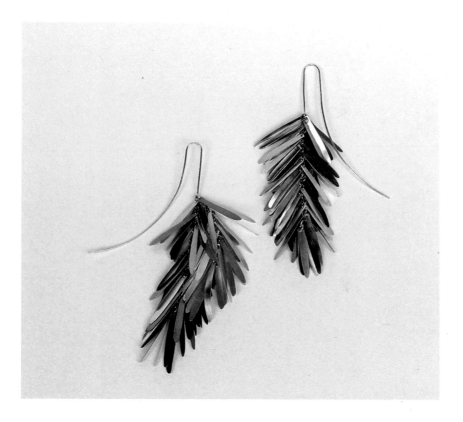

Silver petal earrings, 2006, silver, 3 cm drop

© Jamie Maisey

P.O. Box 2101
Salisbury
Wiltshire SP2 2BT

mob. 07799 250888
email katharinewarner@mac.com

JACQUELINE **WARRINGTON**

Jacqueline Warrington's jewellery has been seen in many exhibitions, galleries and, most importantly, on the many people who wear it over the last twenty years. Using fine silver, 18-carat gold and precious stones, her work is inspired by the beautiful seascapes where she lives and works. Having strong connections in silversmithing and employing many traditional techniques, each piece manages to maintain a contemporary feel.

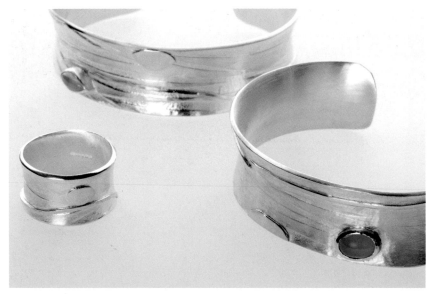

© Wireshots

Two bangles, one ring, 2006, fine silver, 18ct yellow gold and aquamarine, bangles: 2 x 7.5 cm, ring: 1.5 cm wide

34 Main Street
Buckton
East Riding of Yorkshire
YO15 1HU

tel. **01262 850034**
email ja.warrington@virgin.net
web www.jacquelinewarrington.co.uk

Jeanne Werge-Hartley places an emphasis on colour and decoration when designing jewellery. She creates three-dimensional pieces using and often combining silver, coloured golds, gemstones, transparent *cloisonné* and *plique a jour* enamels. Jeanne is a founder member of the Designer Jewellers Group and the British Society of Enamellers, the author of *Enamelling on Precious Metals* published by Crowood Press and a Freeman of the Worshipful Company of Goldsmiths.

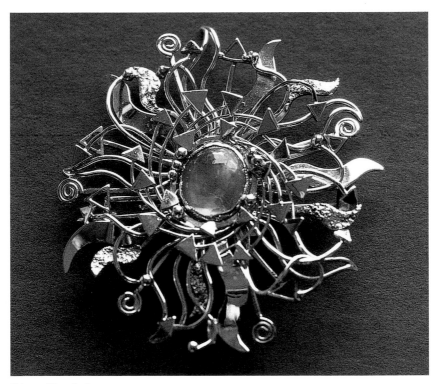

© Jeanne Werge-Hartley

Explosion, 2006, 18ct gold and a mexican fire opal, 5 x 5.5 cm

© Sarah Macrae

tel. **01243 373586**
email **jeanne@werge.go-plus.net**
web **www.designerjewellersgroup.co.uk**

SHELLEY WERNHAM

Shelley Wernham was born in the Isle of Man and graduated with a BA (Hons) in Applied Arts. Her work is produced using precious and non-precious metals, which are fabricated into designs that stimulate the senses and yet look sculptural on or off the body. Each item is a custom designed personal vessel that contains thoughts or memories kept secure to the holder.

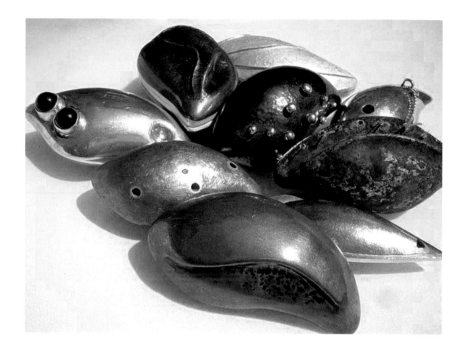

Collective pods, 2004, 18ct yellow gold, silver, brass, copper and gilding metal

mob. **07786 518495**
email shelleywernham@hotmail.com

Stacey Whale, born in New Zealand, delves into the depths of the natural and the microscopic, finding a world of overlooked beauty. The mysterious and the curious merge to form a complex pattern of the organic and the architectural. These fragments of often hidden detail provide a platform of inspiration for Stacey's innovative and original pieces of jewellery.

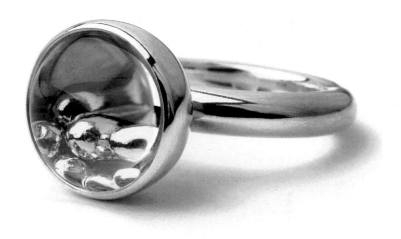

© Marcos Bevilacqua

Gem of a seed, 2006, 9ct white gold, 24ct gold, fine silver and sapphire, 33 cm x dome diameter 1.3 cm

Studio E15, Cockpit Arts
Cockpit Yard
Northington Street
London WC1N 2NP

tel. 020 7209 1375
email stacey@staceywhale.com
web www.staceywhale.com

FRANCES JULIE WHITELAW

Frances Julie Whitelaw studied jewellery and silversmithing at Duncan of Jordanstone College of Art and Design where she started a life long love of working in metal. She uses wire as a medium for creating light and three-dimensional structures. The pieces illustrated are from a cast range of silver jewellery. She also creates individual pieces in gold and undertakes commissions.

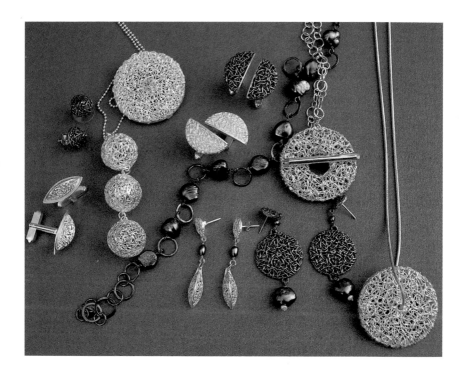

Cast wire selection, 2005–7, silver, from 1–4.5 cm

mob. 07733 378472
email fjw_silver@hotmail.com

DR SANDRA WILSON

An unconventional jeweller, Sandra works with scientists exploring the transformation and creation of form. Her work has won awards from the Audi Foundation, the British European Designers Group, and the Scottish Arts Council. Her skills include computer-aided design and rapid prototyping.
She is also a full-time lecturer and reasearcher at Duncan of Jordanstone College of Art and Design, part of the University of Dundee.

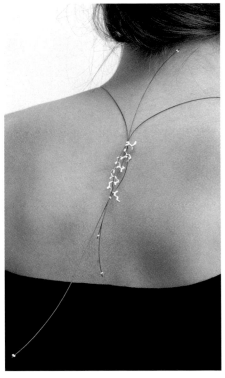

© Malcolm J. Thomson

Pulse protein detail, 2005, red tiger tail wire, silver crimps and sterling silver helix, 83 x 37 cm

© Andy Rice

Dundee
Scotland

mob. **07773 851499**
email **sandra.c.wilson@btinternet.com**
web **www.sandra-wilson.com**

JOSEPHINE WINTHER

Josephine Winther was born in Denmark. She trained as an apprentice goldsmith, followed by a design degree in jewellery. When working with jewellery pieces, the outline is often the starting point; the empty space is equally as important as the solid piece of jewellery. A piece of jewellery is more than shapes and materials, it is interaction of forms with position and context.

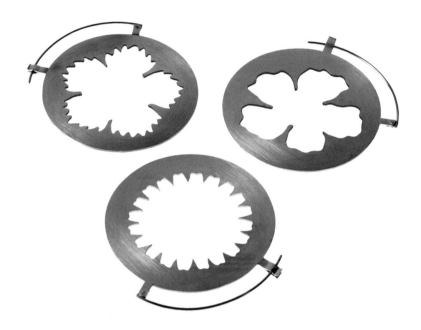

© Dorte Krogh

Flower brooches, 2003, silver, white gold and daylight reflecting paint, 5.75 x 5.75 cm

Klareboderne 12
4 Floor
1115 Copenhagen

tel. 0045 244 33575
email josephinewinther@gmail.com

CLAIRE **WOOD**

Claire Wood's work has a kinetic nature which explores the concept of jewellery as an interactive, playful object. Claire discovered her interest in kinetic jewellery whilst studying for a Jewellery BA (Hons) degree at Buckinghamshire Chilterns University College and continues to create one-off and small batch production kinetic pieces in both precious and non-precious materials for gallery collections and private commissions.

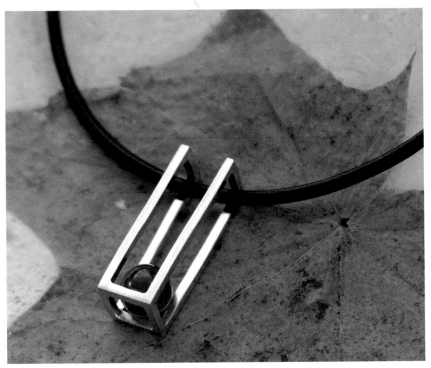

© Lee Harris

Box kinetic pendant, 2006, sterling silver, green agate and rubber cord, 3 x 1.2 x 1.2 cm (w x h x d)

© Dan Wood

mob. **07958 597099**
email **info@clairewood.co.uk**
web **www.clairewood.co.uk**

RUTH **WOOD**

Ruth Wood is inspired by ancient artefacts, irregular form and the erosion of materials. The exploration of reticulation, enamelling and gemstone or glass-setting in her work, results in unique one-off pieces. Materials include: gold, silver, brass, enamel, glass and gemstones. The glass is a recycled element combining disregarded materials with the precious, creating exquisite pieces of jewellery and silverware.

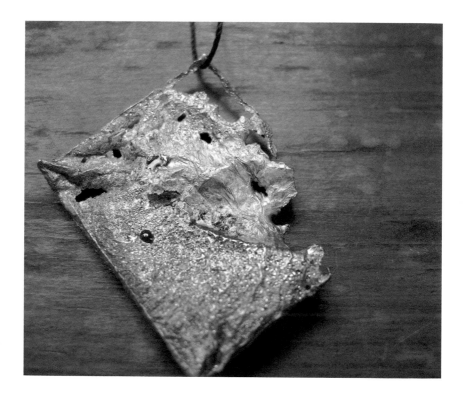

Pendant, 2006, brass, enamel and silk thread, 2.6 x 3.4 cm

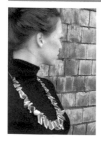

mob. **07832 199596**
email **ruth_wood@hotmail.com**

FIONA **WRIGHT**

Fiona Wright's work is made from recycled newspaper and combines inspiration from the natural world, ecological mindfulness and a joy of material exploration. Each unique piece holds a life cycle of stories. Using only the colour of the print, the paper is either spun or rolled and twisted, by hand, to form a yarn from which the neckpieces and bangles are then developed.

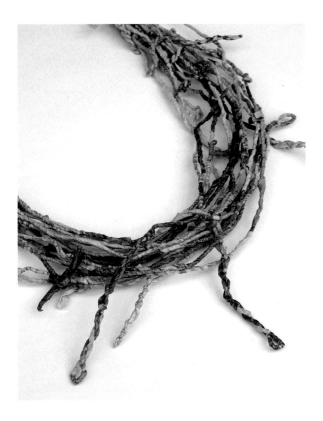

Financial Times neckpiece, 2006. Recycled newspaper and acrylic varnish, 32 cm diameter approx.

35 Fairfield Drive
London SW18 1DL

mob. **07960 792975**
email **fwright2003@yahoo.co.uk**

ANASTASIA YOUNG

Anastasia Young is a graduate of both Central Saint Martins and the Royal College of Art. She specialises in creating intricate and unusual jewellery forms – combining bone, horn or wood with precious metals – and often with a narrative content. The musicbox ring is representative of Anastasia's love of the complicated mechanisms that inhabit the past, and the miniature architecture of such objects.

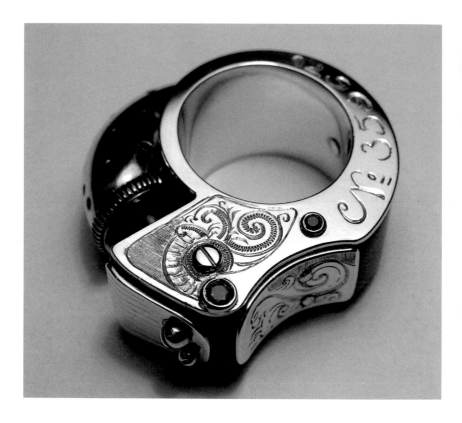

Musicbox ring, 2007, 18ct yellow gold, rubies, sapphires and ebony, 3.5 x 3.5 x 1.5 cm (w x h x d)

mob. 07845 968859
email anastasia.young@virgin.net
web www.cga.org.uk/anastasiayoung

Seeing and buying designer jewellery has never been easier. Most craft galleries stock jewellery as an important selling area, and many hold seasonal exhibitions particularly at Christmas and before Valentine's Day. The gazetteer *Craft Galleries Guide*, published by BCF Books (www.bcfbooks.co.uk) and periodically updated, provides up to date information, arranged by region, on location, opening times, and types of craft stocked. Listings in *Crafts* magazine, *Time Out*, and weekend broadsheet newspapers are an additional source of current information.

Some galleries show jewellery only, and many others have a regular programme of jewellery exhibitions. The following list gives contact details of a selection of these:

Brighton
Turning Heads at Grains of Gold
52 Meeting House Lane
Brighton
BN1 1HB
tel. 01273 772645
www.turning-heads.net

Cardiff
Craft in the Bay
The Flourish
Lloyd George Avenue
Cardiff Bay
CF10 4QH
tel. 029 2048 4611
www.makersguildinwales.org.uk

Edinburgh
The Scottish Gallery
16 Dundas Street
Edinburgh
EH3 6HZ
tel. 0131 558 1200
www.scottish-gallery.co.uk

The Open Eye Gallery
34 Abercromby Place
Edinburgh
EH3 6QE
tel. 0131 557 1020
www.openeyegallery.co.uk

Eton
JaM
81 High Street
Eton
Windsor
SL4 6AF
tel. 01753 622333
www.etonappliedarts.co.uk

Farnham
New Ashgate Gallery
Wagon Yard
Lower Church Lane
Farnham
GU9 7PS
tel. 01252 713208.
www.newashgate.org.uk

Glasgow
Roger Billcliffe Gallery
134 Blythswood Street
Glasgow
G2 4EL
tel. 0141 332 4027
www.billcliffegallery.com

Hereford
John McKellar
23 Church Street
Hereford
HR1 2LR
tel. 01432 354460

Mike Gell Studio
7 East Street
Hereford
HR1 2LQ
tel. 01432 278226
e. mikeygell@hotmail.com

Keswick
The Necessary Angel
Packhorse Court
Keswick
CA12 5JB
tel. 017687 71379
www.artangel.co.uk

Leamington Spa
Jane Moore Jewellery
16 Denby Buildings
Regent Grove
Leamington Spa
CV32 4NY
tel. 01926 332454
www.janemoorejewellery.co.uk

Leeds
Crafts Centre and Design Gallery
City Art Gallery
The Headrow
Leeds
LS1 3AB
tel. 0113 247 8241
www.craftcentreleeds.co.uk

Liverpool
Bluecoat Display Centre
Bluecoat Chambers
School Lane
Liverpool
L1 3BZ
tel. 0151 709 4014
www.bluecoatdisplaycentre.com

London
@ Work
156 Brick Lane
E1 6RU
tel. 020 7377 0597
and 35 Ponsonby Terrace
Pimlico
SW1P 4PZ
tel. 020 7821 9732
www.atworkgallery.co.uk

Aurum
12 Englands Lane
NW3 4TG
tel. 020 7586 8656
e. aurm@barclays.net

Cecilia Colman Gallery
67 St Johns Wood
High Street
NW8 7NL
tel. 020 7722 0686
www.ceciliacolmangallery.com

Contemporary Applied Arts
2 Percy Street
W1P 9FA
tel. 020 7436 2344
www.caa.org.uk

EC-One
41 Exmouth Market
EC1
tel. 020 7713 6185
e. info@econe.co.uk
www.econe.co.uk

Electrum Gallery
21 South Molton Street
W1Y 1DD
tel. 020 7629 6325

Flow Gallery
1-5 Needham Road
W11 2RP
tel. 020 7243 0782
www.flowgallery.co.uk

Goldsmiths'Hall
Foster Lane
EC2V 6BN
tel. 020 7606 7010
www.thegoldsmiths.co.uk

Jess James
3 Newburgh Street
W1F 7RE tel
tel. 020 7437 0199
www.jessjames.com

Lesley Craze Gallery
33-35a Clerkenwell Green
EC1R 0DU
tel. 020 7608 0393
www.lesleycrazegallery.co.uk

Studio Fusion
Unit 1:06 Oxo Tower Wharf
Bargehouse Street
SE1 9PH
tel. 020 7928 3600
www.studiofusiongallery.co.uk

Ruthin
The Gallery
Ruthin Craft Centre
Park Road
Ruthin
Denbighshire
LL15 1BB
tel. 01824 704774

Saltaire
Kath Libbert Jewellery
Salts Mill
Shipley
Saltaire
W.Yorks
BD18 3LA
tel. 01274 599790
www.saltsmill.org.uk

Sawbridgeworth
Gowan Gallery
3 Bell Street
Sawbridgeworth
Herts
CM21 9AR
tel. 01279 600004
www.gowan-gallery.co.uk

Swansea
Mission Gallery
Gloucester Place
Maritime Quarter
Swansea
SA1 1TY
tel. 01792 652016
www.missiongallery.co.uk

Welbeck
Harley Gallery for Art and Craft
Welbeck
nr Worksop
Notts
S80 3LW
tel. 01909 501700
www.harleygallery.co.uk

Windermere
Blackwell
The Arts and Crafts House
Bowness on Windermere
LA23 3JT
tel. 01539 446139
www.blackwell.org.uk

In addition there are good representations of designer jewellery in the many crafts fairs held throughout the country during the year, some dedicated to designer jewellery and all providing opportunities to meet and talk to jewellers. Important regular fairs include the following:

Collect, in February at the Victoria and Albert Museum, www.craftscouncil.org.uk/collect

British Crafts (pre-Christmas and April) www.britishcrafts.co.uk

Desire, in March, www.craftinfocus.com.

The Contemporary Craft Fair, Bovey Tracey, Devon, in June, www.craftsatboveytracey.co.uk

Art in Action, in July at Waterperry, Oxon, www.artinaction.org.uk

Goldsmiths Fair (early October), www.thegoldsmiths.co.uk

Origin (Crafts Council with Somerset House, in mid-October) www.craftscouncil.org.uk/origin

Designer Crafts @ Chelsea, (mid-October) www.societyofdesignercraftsmen.org.uk

Dazzle, National Theatre in Nov/Dec, Manchester in May, Edinburgh in August.
Details and dates: www.dazzle-exhibitions.com

The many communal workshops around Britain hold regular **Open Studio** events, usually advertised in the local press. In London the principal open studios are those presented at midsummer and in late autumn by Cockpit Arts, www.cockpitarts.com, and by Clerkenwell Green Association, www.cga.org.uk.

College **Degree Shows** in June and July afford opportunities for spotting emerging talent in local colleges, while **New Designers** in early July at the Business Design Centre, Islington shows the cream of degree work all in one place at the same time. www.newdesigners.com

JH: The Rings Book
Jinks McGrath
Re-issued December 2007

JH: Resin Jewellery
Kathie Murphy
Reprinted 2006

JH: Wire Jewellery
Hans Stofer
2006

JH: Enamelling
Ruth Ball
2006

JH: Natural Materials
Beth Legg
September 2008

JH: Bangles and Bracelets
Amanda Doughty
December 2008

**JH: Jewellery from
Recycled Materials**
Jaimie MacDonald
November 2008

OTHER FORTHCOMING TITLES:
JH: Brooches
Sarah Stafford July 2009

Design and Make: Non-Precious Jewellery
Kathie Murphy February 2009

Design and Make: Mixed-Media Jewellery
Joanne Haywood May 2009

Design and Make: Jewellery using Textile Techniques
Sarah Keay July 2009

www.acblack.com